IMAGES
of America

MARIN COUNTY

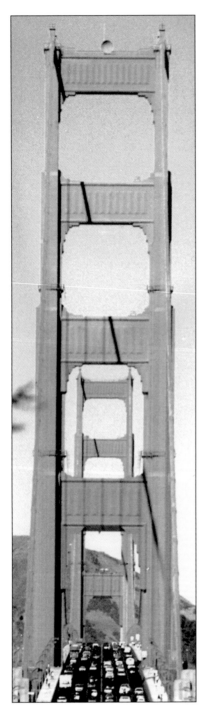

Man and nature have combined to create an extraordinary place called Marin County, California. (Courtesy author's collection.)

ON THE COVER: Frank Lloyd Wright dreamed of connecting two small round hills with a series of arches to create the Marin County Civic Center—his last great design. (Courtesy author's collection.)

IMAGES
of America

MARIN COUNTY

Branwell Fanning

ARCADIA
PUBLISHING

Published by Arcadia Publishing
Charleston, South Carolina

Printed in the United States of America

Library of Congress Catalog Card Number: 2007929237

For all general information contact Arcadia Publishing at:
Telephone 843-853-2070
Fax 843-853-0044
E-mail sales@arcadiapublishing.com
For customer service and orders:
Toll-Free 1-888-313-2665

Visit us on the Internet at www.arcadiapublishing.com

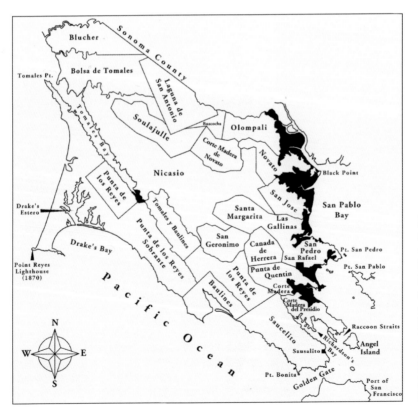

Marin County's original ranchos were granted by Mexico between 1834 and 1846. This map was drawn by Jeila Joslyn in 2004. (Courtesy Anne T. Kent Room Collection, Marin County Free Library.)

CONTENTS

ACKNOWLEDGMENTS

Few places have been studied to the extent that historians have examined California. We are fortunate in that some of the early historians had firsthand access to the people and documentation that make up California's history. In 1884, Hubert Howe Bancroft wrote his nine-volume *History of California* while some of the participants in the revolt from Mexico were still alive. Important documentation and personal correspondence was still available and was included verbatim in the publication.

Other invaluable reference material includes Jack Mason's *Early History of Marin*; Barry Spitz's *Mill Valley, The Early Years*; and Lincoln Fairley's *Mount Tamalpais, A History*. Two remarkable books, *Bear Flag Rising* by Dale L. Walker and *Chief Marin* by Betty Goerke, demonstrate extensive research and yet remain eminently readable.

About 75 percent of the images have come from my personal collection; however, the Marin History Museum, the primary depository of thousands of photographs of life in Marin County, was most generous in allowing me to select the images to tell the story of the period before I was born, as was the Belvedere Tiburon Landmark Society. Laurie Thompson, librarian at the California Room at the Civic Center Library, was as usual helpful in all ways.

I would like to thank John Poultney, my editor at Arcadia Publishing, for his help and guidance, and my wife, Carolyn, for her reading and rereading my copy for errors in spelling, grammar, and punctuation. She also did extensive research to help write several chapters.

INTRODUCTION

The reader of this book should keep in mind that when placed on the tapestry of world history, Marin County, California, is a newcomer. What we consider "historic" may be only 50 to 100 years old. Something 200 years old is part of ancient history. When I was a small boy, we would spend our summers in Salem, Massachusetts, so I got indoctrinated into early American history long before settling in Marin County. Salem had been hanging witches almost 100 years before the first Spanish sea captain, Juan Manuel Ayala, a lieutenant in command of the *San Carlos*, ventured though the Golden Gate and anchored his ship in a cove off an island in a California wilderness that was inhabited only by Coast Miwok tribes.

The notorious British pirate Francis Drake had landed somewhere in Marin County in 1579, claimed it for England, and named it New Albion. The exact spot of his landing has been in dispute ever since. Drake, not yet knighted, was on a round-the-world cruise to harass and plunder Spanish shipping and colonies in the New World. To avoid the pursuing Spanish fleet, he decided to go back to England by sailing west across the Pacific. His ship, however, was in no condition to make the long voyage. In order to complete repairs, he careened the *Golden Hind* on a Marin County beach, most likely at Point Reyes. England did not capitalize on Drake's claim, and European settlement came 200 years later, when Ayala sailed into San Francisco Bay in 1775.

In 1595, the Spanish galleon *San Augustin* came ashore in Marin County. It was loaded with treasure from the Far East, and like the *Golden Hind*, the *San Augustin* was battered and leaky and sought shelter in a coastal bay. However, its captain did not enter the protected waters of Point Reyes, and a fierce November storm drove his ship onto the beach where it was battered to pieces. Parts of the hull and bits of Oriental porcelain have washed ashore ever since.

The landscape of Marin County has been formed by the massive movement of the continental plates on the surface of the earth. Mount Tamalpais, the dominant physical feature of the county, was formed by the collision of the Pacific plate with the North American plate eons ago. The San Andreas Fault divides these two plates and much of the Pacific coast of the county from the main body of land. An obvious feature of a map of North America is a series of bays running in a straight line along this fault between Baja California, and the 12-mile-long Tomales Bay, which separates Point Reyes from mainland Marin County.

The Pacific side of this great fault is moving north at an average rate of about 2 inches a year. When a strain builds up and lets go all at once, as it did in 1906, a massive earthquake results. While the destruction in that quake was greatest in San Francisco, the earth movement was greatest in rural Marin County. Roads buckled and fences were offset by as much as 20 feet in some parts of western Marin.

The abundance of the land—plentiful deer, elk, and bear for the hunters, several varieties of shellfish, birds and fish of all types, and acorns to be pounded into mush—provided ample food for the Miwoks. A mild climate required little in the way of clothing or housing. As they required nothing that the land and sea did not provide, the Miwoks lived at peace with their neighbors. When the first explorers arrived from Spain, they were greeted with friendliness and hospitality.

After Ayala's exploration of San Francisco Bay, Spain realized the potential of this magnificent port and immediately set about fortifying the entrance to the bay and settling the land. The Spaniards established a chain of missions from San Diego to Sonoma as the base for their settlements. Within a few years, the Miwoks were relocated to the missions, but sadly, European diseases to which they had no immunity claimed most of them. Those Miwoks that survived faced the closing of the missions a few years later, then went to work on the ranches, but soon blended into other cultures.

Spain divided Northern California into large ranchos centered around the newly established missions. Because of Marin County's favorable climate, Mission San Rafael Archangel was founded to act as a retreat for settlers and missionaries who had problems with the damp and foggy conditions at Mission Dolores and the Presidio in San Francisco. The settlers were Mexican citizens, but with few exceptions, they originally hailed from the British Isles or were Mexicans born in California. They were all called "Californios."

The Russians, in the meantime, were coming down from the north looking for outposts that could provide supplies for their colony in Alaska. By 1812, they were in Sonoma County at Fort Ross. With the Russians in Fort Ross and the Spanish in San Francisco, the gap in the middle was filled by many settlers from the British Isles and Americans coming over the mountains who qualified for land grants after Mexico gained its independence.

Early Marin County became popular with the crews of the whaling fleets and trading vessels visiting San Francisco Bay. Cold clear water gushing down the hillsides filled the tanks on board these ships, and the forests that covered the hillsides provided firewood for cooking stoves while in port and to stock up before sailing on lengthy voyages. Unfortunately, with the removal of the forest cover, the topsoil washed down into the valleys below and filled some of Marin's numerous streams completely.

In 1821, Mexico revolted and gained its independence from Spain. Newly independent Mexico confiscated the mission properties, but the control of California would not last long. According to Hubert Howe Bancroft's *History of California*, by 1846, the mix of settlers, Mexicans, and Californios all realized that political change was imminent. Remaining a part of Mexico was no longer an option. This change would either be in the form of complete independence or annexation by a foreign power. The Mexican governor favored annexation by England, the military commander favored France, and most of the recent settlers favored the United States. The Californios preferred the status quo but realized that it could not last.

In the haste to distribute these remote and rugged lands while still under his control, the Mexican governor granted title to all the land in Marin County to friends, military figures, and settlers, most of them from Great Britain, between 1834 and 1846. These grants were huge; many would be worth billions of dollars today.

Maps were drawn by friends and neighbors with no training, surveys were done on horseback, and title was claimed by the casting of stones. These chaotic conditions led to continuous litigation later. Many of the original grantees lost all of their property to the lawyers who carried their cases through the courts and accepted land in lieu of fees.

The 21 land grants are listed from south to north. Some grants overlapped the county borders and the acreages are for the Marin County portion only.

RANCHO SAUSALITO. GRANTEE: WILLIAM RICHARDSON, ENGLISH, 19,571 ACRES, 1835. Includes Sausalito, Marin City, Muir Beach, Muir Woods, Stinson Beach, southern Mill Valley, and the coastal fortifications. Richardson ran up huge debts and mortgaged the property. By 1855, he lost most of it in foreclosure to Samuel Throckmorton. It was Throckmorton who developed the town of Mill Valley. The 640 acres Richardson left to his wife were sold to develop the city of Sausalito.

CORTE MADERA DEL PRESIDIO. GRANTEE: JOHN (JUAN) REED, IRISH, 7,845 ACRES, 1834. Includes Belvedere, Tiburon, Mill Valley north of Miller Avenue, Corte Madera, and Old Larkspur. The Reed family held on to much of this ranch until World War II. The last of the original family members, Clotilda Reed, still owned more than 2,000 acres of Tiburon when she died in 1940.

ANGEL ISLAND. GRANTEE: ANTONIO OSIO, CALIFORNIO, 740 ACRES, 1839. Includes part of the town of Tiburon. The island had been reserved for military use. In 1860, the U.S. government claimed it and built several Civil War–era forts. Later quarantine and immigration stations, World Wars I and II embarkation camps, and a Nike missile base were built. The island was included in the Golden Gate National Recreation Area but was turned over to the State of California as a state park.

PUNTA DE QUINTIN. GRANTEE: JOHN ROGERS COOPER, ENGLISH, 8,894 ACRES, 1840. Includes San Quentin prison, part of Larkspur, Greenbrae, Ross, Kentfield, and part of San Anselmo. Cooper sold this ranch in 1850. It was then sold to James Ross, who developed the land.

CANADA DE HERRERA. GRANTEE: DOMINGO SAIS, CALIFORNIO, 6,660 ACRES, 1839. Includes part of San Anselmo and Fairfax. Harvey Butterfield leased 1,900 acres, which became Sleepy Hollow. Thirty-one acres were sold to Lord Charles Fairfax for $5.

SANTA MARGARITA, LAS GALLINAS, SAN PEDRO. GRANTEE: TIMOTHY MURPHY, IRISH, 21,680 ACRES, 1844. Includes San Rafael, St. Vincent's, Lucas Valley, Terra Linda, Las Gallinas, Point San Pedro, and Marinwood. Don Timoteo Murphy was a huge man who dominated central Marin for decades. He gave most of his land to relatives and founded and funded St. Vincent's Orphanage.

SAN GERONIMO. GRANTEE: RAFAEL CACHO, CALIFORNIO, 8,723 ACRES, 1844. Includes San Geronimo, Woodacre, Forest Knolls, and Lagunitas. Navy lieutenant Joseph Warren Revere, grandson of Paul Revere, fell in love with the San Geronimo Valley while on a survey trip and bought it in 1846. Adolph Mailliard, grand nephew of Napoleon Bonaparte, purchased the ranch in 1867. Adolph's great-grandson William S. Mailliard represented Marin County and San Francisco in the U.S. House of Representatives for 22 years and was the house leader in creating the Golden Gate National Recreation Area and the Point Reyes National Seashore.

TOMALES Y BAULENES. GRANTEE: RAFAEL GARCIA, CALIFORNIO, 9,405 ACRES, 1836.

BAULENES. GRANTEE: GREGORIO BRIONES, CALIFORNIO, 8,920 ACRES, 1846.

PUNTA DE LOS REYES. GRANTEE: JAMES BERRY, AMERICAN, 22,525 ACRES, 1836.

PUNTA DE LOS REYES SOBRANTE. GRANTEE: ANTONIO OSIO, CALIFORNIO, 48,190 ACRES, 1843. Includes Bolinas, Olema, Point Reyes Station, Inverness, Point Reyes National Seashore, and much of the Golden Gate National Recreation Area (GGNRA). Unfortunately, the legal descriptions of the four grants overlapped, and the grantees were never able to agree on who owned which land. Mired in litigation, they gave up, and by 1856, Vermont attorneys Oscar Shafter and his brother owned these ranches and other property totaling 93,198 acres, or one fourth of Marin County. They leased large portions to ranchers who agreed to use the property as dairies. Most of the ranches changed hands several times before becoming the foundation of the federal parks

NICASIO. GRANTEE: DE LA GUERRA, SPANISH, AND JOHN COOPER, IRISH, 56,807 ACRES, 1844. Includes Nicasio, the east shore of Tomales Bay, part of Novato, and vast ranch lands. Originally promised to the Miwok tribes, there were several swindles ending with the grant going to De La Guerra and Cooper. They broke the ranch into large parcels, and by 1851, the two had sold it all off. The Miwoks received the right to live on about 30 acres and to hunt and fish on the ranch but not raise cattle.

SAN JOSE. GRANTEE: IGNACIO PACHECO, CALIFORNIO, 6,660 ACRES, 1840. Includes part of Novato, Ignacio, and Hamilton Field. Part of the ranch is still owned by Pacheco's descendants.

NOVATO. GRANTEE: FERNANDO FELIZ, CALIFORNIO, 8,870 ACRES, 1839. Includes most of Novato proper. Feliz sold the ranch in 1844.

CORTE MADERA DE NOVATO. GRANTEE: JOHN MARTIN, SCOTTISH, 8,878 ACRES, 1839. Includes part of Novato and Hicks Valley.

OLOMPALI. GRANTEE: CAMILO YNITIA, MIWOK TRIBE, 8,878 ACRES, 1843. Includes Olompali State Park. The only Native American to receive a land grant, Ynitia sold large pieces of the ranch, keeping 1,480 acres for his family.

BUACOCHA. GRANTEE: TEODORA DUARTE, CALIFORNIO, 2,584, c. 1846. Includes area that straddles the road between Point Reyes and Petaluma. This was the only grant to a

woman. After 10 years of litigation, the court stripped the Duartes of the land, opening it up to homesteaders.

SOULAJULLE. GRANTEE: RAMON MESA, CALIFORNIO, 13,338 ACRES, 1844. Includes the Soulajulle Reservoir of the Marin Municipal Water District. By 1850, Mesa had sold the entire ranch.

LAGUNA DE SAN ANTONIO. GRANTEE: BARTOLOME BOJOURQUES, CALIFORNIO, 15,835 ACRES, 1845. Includes open ranch lands. A dispute over the accuracy of the original survey led the court to deny the grant in 1859, leaving the property open to homesteading.

BOLSA DE TOMALES. GRANTEE: JUAN PADILLA, CALIFORNIO, 21,340 ACRES, 1846. Includes Tomales and Dillon Beach. Litigation over the legality of the grant lasted until 1863, with Padilla losing all rights to the land and more than 100 squatters receiving title to the ranches they were occupying.

BLUCHER. GRANTEE: JEAN VIOGET, SWISS, 13,595 ACRES, 1844. Includes Estero San Antonio and Estero Americano, which is the border with Sonoma County. In 1846, Vioget sold the ranch to Steven Smith of Bodega.

When California gained statehood, Marin County was carved out of Sonoma County as one of the original counties. In dividing Sonoma, Gen. Mariano Vallejo named the new county "Marin," supposedly after a Coast Miwok boatman known in Spanish as "El Marinero." He was also known as Marino and later Chief Marin.

Modern Marin County is noted for it affluence, beauty, and liberal politics. Its location between the Pacific Ocean on one side and the San Francisco and San Pablo Bays on the other, with beautiful hills and valleys in between, provides a smorgasbord of recreational possibilities. Housing prices are outrageous by the standards of the rest of California and most of the United States, but with reportedly the highest per capita incomes in the country, families are still locating here.

Marin County is surrounded by several major metropolitan areas with internationally recognized symphony, opera, and ballet companies; museums and art collections; great universities such as the University of California–Berkeley, Stanford, and the University of San Francisco; and shopping and entertainment centers. World-renowned medical centers at Stanford and the University of California at San Francisco are close by. To the north is the wine country of the Napa and Sonoma Valleys. The Monterey Peninsula and Pebble Beach are less than three hours to the south, and Yosemite, Lake Tahoe, and the Sierra ski runs are three hours to the east.

The original inhabitants called the various parts of Marin County by a wide variety of names, depending on the tribe. The original settlers used just as many different names. Throughout this book we will identify places by the names most commonly used today except where otherwise noted and will avoid repeating "now known as."

One

THE LANDSCAPE

Marin County has to be one of most advantageously located places on earth. The Pacific Ocean washes its western shore in breathtaking beauty when the seas are peaceful. Coastal mountains protect residential areas when winter storms blow in force. The southern boundary is the most dramatic entrance of any of the great harbors of the world—the Golden Gate. California's wine country begins at its northern edge.

Marin County's eastern side fronts on San Francisco Bay, renowned all over the world for its beauty. Part of that beauty is created by the Mediterranean-styled villages of Sausalito and Tiburon. Inland from the Bay are the "woodsy" villages of Mill Valley, Larkspur, and the Ross Valley.

Mount Tamalpais, at 2,604 feet, is the dominant physical feature of the county. It runs east and west across the grain of a 1,000-mile-long coastal range and is visible from almost any point in the county. Creeks flow down the slopes of Mount Tamalpais (commonly called Mount Tam) on all sides, ultimately emptying into the bay or ocean. Creeks were the source of fresh water to fill the casks of whalers and traders who wintered in Marin County, irrigate the fields of early settlers, and power the sawmills that cut the huge stands of timber that covered most of Marin. That lumber built and rebuilt San Francisco.

The long Pacific coastline has been compared to the Amalfi Drive in Italy for its dramatic lookout points. It is now protected by huge federal and state parks and county watersheds. Several small villages provide colorful breaks and places to rest. The entire Pacific coast of Marin County is part of a 5,300-square-mile marine sanctuary. More than 80 percent of Marin's land area is permanently protected by parks, agricultural easements, or public open spaces.

Nothing has been more important to present-day residents of Marin County than the preservation of the environment. Unfortunately, the early settlers were not preservationists, and much of the great redwood forests and many clear-running streams are gone. Preserving what was left and reintroducing what was lost have been a priority in recent years. Vast sanctuaries and open-space preserves have been created to protect wildlife and native plants.

Two hundred species of birds have been identified in Marin County's forests, canyons, and sanctuaries. The Marin Mammal Center, Wild Care, and the Richardson Bay Audubon Sanctuary care for sick and injured wildlife. Muir Woods is one of the last stands of old-growth redwoods.

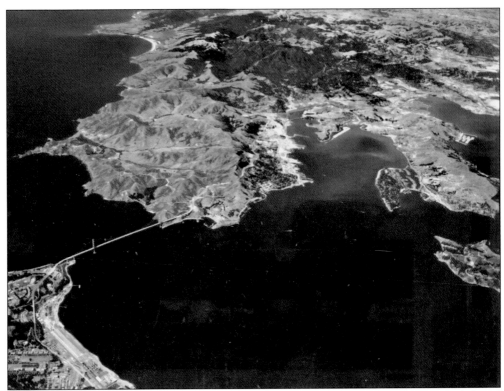

This aerial view of Marin County looks down on Richardson Bay with Sausalito on the left and Belvedere and Tiburon on the right. Behind them are the forested areas of the Mill and Ross Valleys. The rugged nature of the Headlands is visible on the north side of the Golden Gate. The long sweep of the Pacific coast leads to the Bolinas Lagoon and Stinson Beach and the beginning of the Point Reyes Peninsula.

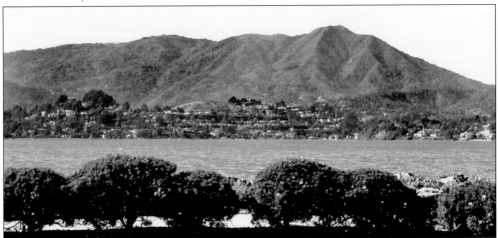

While there is no agreement about the source of the name for Mount Tamalpais, there was a local Miwok tribe named the Tamals, and *país* means region or land in Spanish, so it is possible that the early settlers, speaking Spanish, referred to it as the "land of the Tamals." It was a sacred site to the Miwoks, whose traditions had it as the home of their god, Coyote. Now Mount Tamalpais is locally known as Mount Tam.

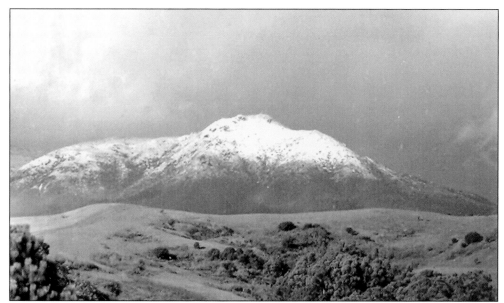

Once every decade or two there is a brief dusting of snow on Mount Tam, as shown in this 1974 image. Pacific storms first run into the mountain and dump their load of water. Dozens of creeks carry it down the slopes, forming ever-larger creeks and estuaries as they merge in the flatlands or beaches.

The slopes of Mount Tam and the rest of Marin County were heavily wooded when the first Europeans arrived. The need for firewood for cooking stoves on sailing ships and lumber to build San Francisco combined to strip Marin of old-growth redwoods, oaks, and aspens within a few years. A few pockets, such as Muir Woods, survive.

The Earthquake Trail on the Point Reyes National Seashore illustrates the earth movement on the San Andreas Fault during the 1906 earthquake. A fence line (above) is offset by about 20 feet. Rocks on the west side of the trail, which is moving north, are representative of Southern California, while those on the east resemble mainland North America.

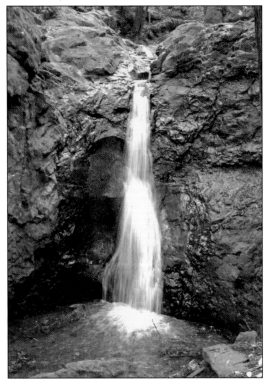

A few of the streams flowing down the sides of Mount Tam create picturesque waterfalls such as this one in Cascade Canyon, Mill Valley. Most of the water drains to the San Francisco Bay or the Pacific Ocean, but enough is stored in man-made lakes to provide drinking water for southern Marin County.

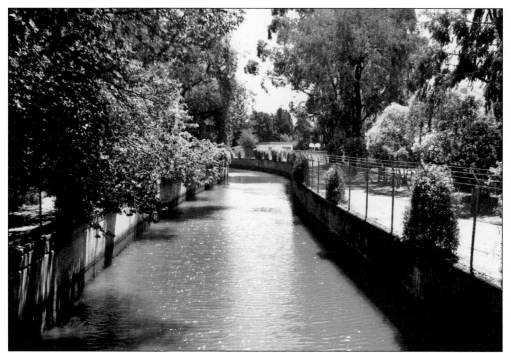

The slopes of Mount Tam facing the Ross Valley spawn a number of streams that lead to Corte Madera Creek, which in pioneer days was navigable to this point in Kentfield. Ross Landing, where the College of Marin is today, was one of the busiest seaports in California. Rainfall varies throughout the county but only rarely falls in the summer.

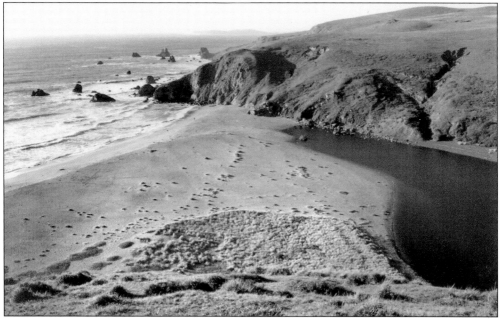

On the Pacific side of Mount Tam, estuaries are formed that are subject to tidal action. Lack of rain in the summer causes some of these to close, creating sandy beaches. They open again in the fall, providing habitat for salmon and other fish to spawn.

In spite of 150 years of development, most of Marin County is still open grazing land, even in the national parks. One hundred thousand head of cattle, both dairy and beef, and lambs and wool are the main products. Horses are no longer used in commerce, but West Marin has numerous riding stables, and many ranchers still keep horses for riding and for show.

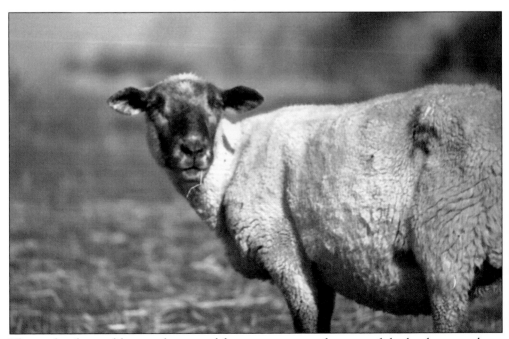

The market for wool has not been good for many years, so the most of the herds are made up of ewes that produce one or two lambs for market each year. Coyotes are a constant threat to the ranchers.

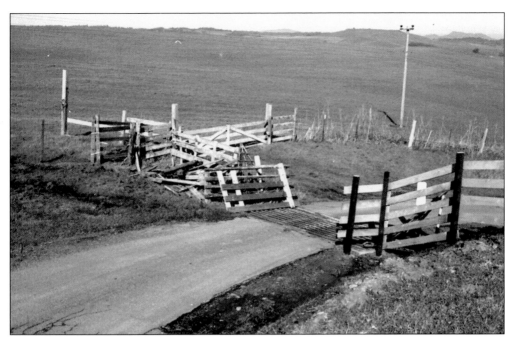

You know that you are in ranch country when you find the roads are crossed by cattle guards.

The Franciscan Formation is the dominant rock form in most of Marin County. It is soft, flaky, and not suitable for building. Limestone outcroppings appear in several locations, principally Angel Island, where it has been quarried out, and at the end of the San Pedro Peninsula.

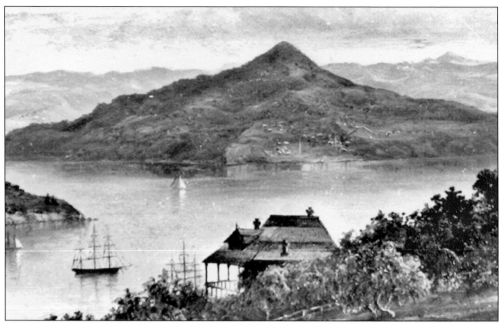

The largest island in San Francisco Bay is Angel Island. The first safe harbor for the *San Carlos* in 1775, the island was soon a favorite with Russian and Yankee whalers seeking water and firewood. When originally granted to Antonio Osio, the Mexican governor added a stipulation that reserved it for military use. When California became a state, the United States exercised that option and took possession of the island.

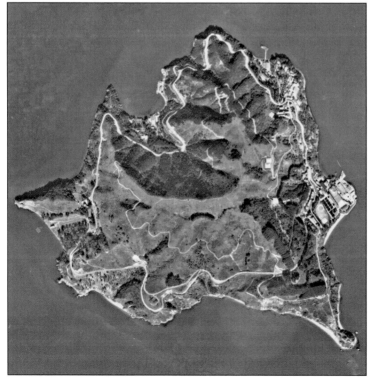

Gun batteries were mounted on Angel Island during the Civil War as part of the fortifications against any Southern attack or by the British Pacific Fleet lurking offshore. A possible small pox epidemic coming from a passenger from the Orient caused the quarantine station to be built on the island. For about 30 years, all arriving Chinese were processed at the Angel Island Immigration Station. The island is now a state park.

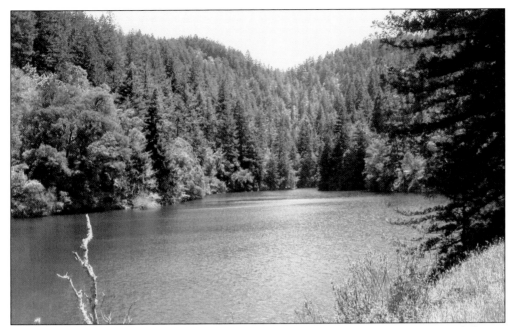

Most of Northern California gets its water from the Sierra Nevada. Marin County is different. In 1912, residents voted to create the Marin Municipal Water District (MMWD), the first municipal water district in California. The Alpine Dam was constructed above Fairfax to create the first of several lakes that rely on the watershed of Mount Tam. A side benefit of the MMWD is the thousands of acres of open space in the watershed available (with certain restrictions) for hiking and camping.

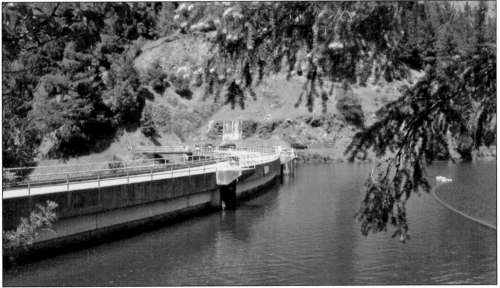

Some of the purest drinking water in the world backs up behind the MMWD dams. Most years the rain is enough, but there have been drought years when rationing was necessary. In the 1970s, a drought was so severe that a pipeline was placed on the Richmond Bridge to bring in extra water from Contra Costa County. A portion of northern Marin County gets its water from the Eel River.

The road from the eastern part of Marin County to the Pacific coast passes the mountain lakes of the MMWD. The rural roads are scenic and fun. Places to camp and picnic are plentiful, and bicycle and hiking trails cover the mountainside.

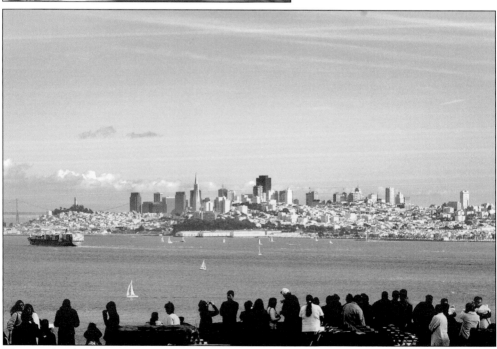

Thousands of visitors come to Marin County just to look across the water at the city of San Francisco. The proximity to this vibrant, world-famous city is one of Marin's greatest assets.

Two

THE FIRST RESIDENTS

The British pirate Francis Drake was the first outsider to visit Marin County, as far as any historical record can be found. Because his ship, the *Golden Hind*, had a severe leak, it had to be completely unloaded before it could be careened on the beach. Drake moved all the gold and silver he had looted from the Spaniards to a small fort. Drake's visit lasted from June 18, 1579, until July 23, 1579, according to the diary of Francis Fletcher, the chaplain of the *Golden Hind*.

This was the first contact by people from the outside with the Coast Miwok tribes. Because of their pale skin, the Miwoks thought that Drake and his crew were dead and "ghosts" of their ancestors but not gods.

Most Miwoks lived in village groups of about 30 except Olompali (just north of Novato), which was larger. Their villages were called *rancherías* by the Spanish and Mexicans, and partially formed the basis for the mission land divisions. Miwoks lived entirely off the land. Settlements were nearly always near fresh water and oak trees. They killed deer and elk and an occasional bear, and they used the entire animal for food and what little clothing they wore. Women dressed in deer and otter pelts; men were mostly naked. Wild birds, fish, and wild berries were plentiful.

Clamshell necklaces were worn by the women, but their main use was for trade with neighboring tribes. The leader of a tribe was called the *hoipu*. While the Miwoks were considered a peaceful people, a *hoipu* traveled with a guard of "100 tall and strong men," according to Fletcher.

When the Spanish arrived, they moved the natives into compounds surrounding their missions. Diseases for which the natives had no immunities soon claimed the lives of a great many Miwoks. In the 1820s, there were battles between the Mexicans and the Miwoks. The last stand by the Miwoks was lead by a warrior named Quintin, captured on the point named after him. When the Mexicans seized the missions, the few survivors worked on the ranches until the last Miwoks in Marin County married into other cultural groups.

Kule Loklo

Ever wondered what it was like to live here two hundred years ago?

Kule Loklo was one of the offshoots of the Coast Miwok tribe in the Point Reyes area. Archeologists have identified at least 600 sites in Marin County where the Miwoks had villages at one time or another. The Tamals (Tomales Bay), Olema, and Olema-loke tribes have left their names on west Marin locations. A skilled Miwok boatman was called el Marinero by the Spaniards and later Chief Marin by the Californios. When California joined the United States, General Vallejo named the area Marin County after the Miwok leader.

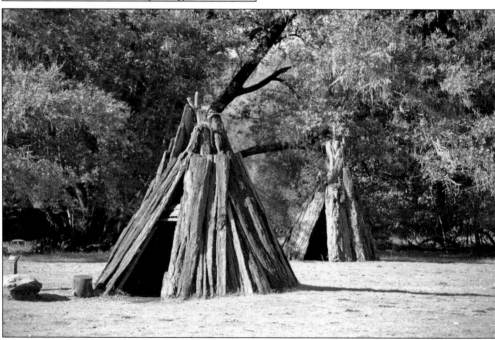

About 30 families made up a Miwok village. They used long strips of redwood bark to construct shelters like these built by descendants at Point Reyes. Several generations of a family would live in one of these shelters. They would build fires inside for warmth, but most cooking and other activities were outside. They also built slightly larger round houses out of bundles of grass. A similar structure stored the family's supply of acorns.

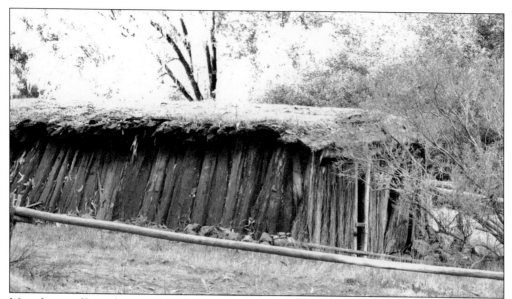

Most large villages had semi-buried dance houses used for various ceremonies. People from smaller settlements would also gather for boys' initiations and other celebrations. Sweathouses were similarly constructed but used, as the name implies, for spiritual purification by the men. In a practical use, hunters would spend time in the sweathouse, followed by a harsh scrubbing, to remove human odors before stealthily approaching game animals.

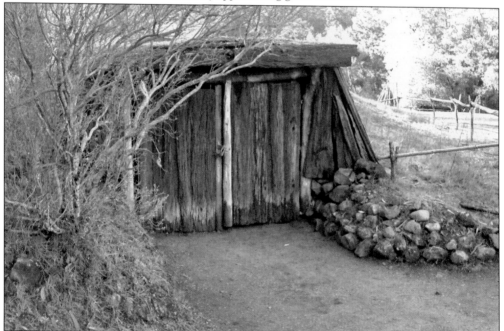

The entrance of the Point Reyes dance house was made of driftwood. When a girl reached puberty, she was confined to a small house and then brought to a dance house where a special dance was held for her. She was then ready to be married. An initiation ceremony for boys occurred when enough seven- and eight-year-old boys could be rounded up from nearby villages. They were no longer considered babies after the ceremony.

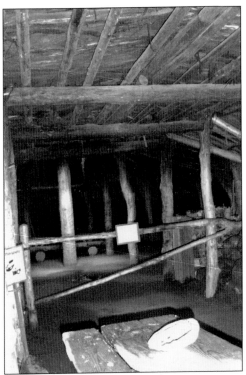

A wood frame covered by a sod roof created a space for larger gatherings in this dance house. The dances were highly structured ceremonies, some performed only once each year. A special dance was held on "seed day," when flowers began dropping seeds. Three men and three women danced while two men and two women sang. All wore coats of pelican skins.

There was also a rear exit from the dance house. Women did the food preparation in a Miwok village while the men were hunting and fishing. A piece of obsidian, probably from the St. Helena area, was valuable, and the men spent many hours "flint-knapping," or flaking off bits of glass to make arrow points. Men also made the strings of shell beads used for money by tribes beyond Marin County.

Anthropologists classified Coast Miwoks as "hunter-gatherers," and that is how they survived for thousands of years. The oak-covered hillsides provided an endless supply of acorns that became the staple in their diet. Inedible when picked up, the acorns were pounded in mortars such as this one found in Southern Marin until the shell was broken, exposing the meat of the nut. After further pounding into flour and leaching in water, it was baked or made into mush.

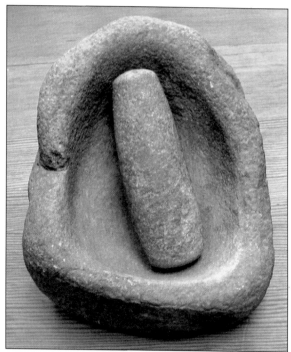

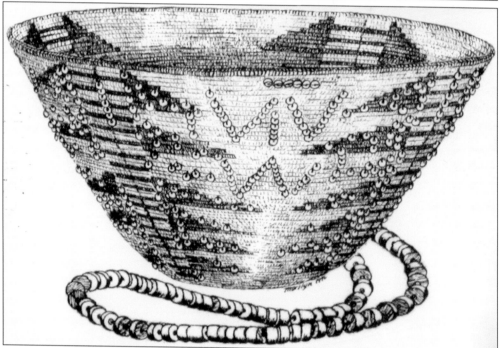

The Point Reyes Miwok tribes were famous for their fine basketry. Pottery was not part of their culture, so the gathering of acorns, seeds, and fruit was done using baskets made out of grass and reeds. They were woven so tightly that they could hold water. Cooking was done by dropping hot rocks from the fire into a water-filled basket and adding food. The only surviving examples of Miwok basketry are in St. Petersburg, Russia.

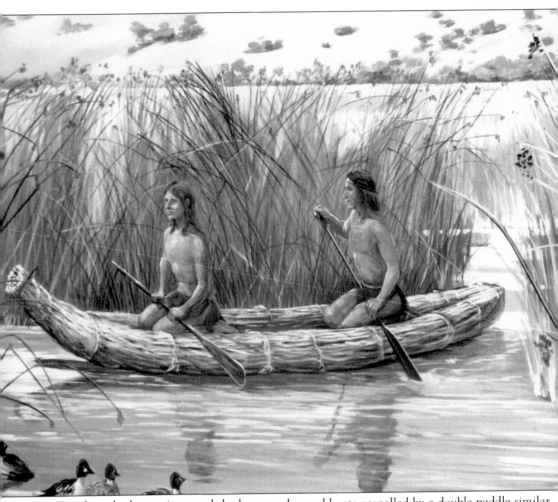

Travel on the larger rivers and the bays was by reed boats propelled by a double paddle similar to an Eskimo's kayak. Like the baskets, the reeds were woven so tightly that the boat would float until the reeds became waterlogged. These boats were the main means of communication between settlements even into the mission period. This drawing is part of a mural of Miwok life at the Bay Model in Sausalito.

Three

PIONEERS AND RANCHERS

The first of the land-grant settlers was John Reed in 1834, followed in 1838 by William Richardson on Rancho Sausalito. Between them, Reed and Richardson owned all of southern Marin County from Raccoon Strait to the Pacific Ocean. Reed hung onto his land, but Richardson lost his in a series of maritime ventures and land speculation. All the other land grantees had taken possession of their vast ranches by 1845. For most, life was good. Regardless of their country of origin, they became part of a group of Spanish-speaking Mexican citizens known as Californios, who adopted the relaxed lifestyle of Mexico with their large estates, herds of cattle and horses, frequent fiestas, rodeos, and gracious living.

All was not well in other parts of the Mexican empire. Texas had revolted, and a shooting war had erupted on the Rio Grande. American settlers were moving west into New Mexico and over the Sierras into California. The Mexican government declared that all of their colonies, including Alta California, would have to be self-sustaining, which meant no effective government.

It took months for news or instructions to get over the mountains or around Cape Horn, so American officials were given confidential instructions and granted "large discretionary power." A band of frontiersmen, including Kit Carson, roamed the area under the command of John C. Fremont. Officially they were making a topographical survey, but Fremont was under secret instructions from Pres. James Polk should war break out to expand U.S. control into the territory. These instructions followed the idea of "Manifest Destiny," the claim that the U.S. government should control all territory from the Atlantic to the Pacific.

A feeble attempt by Mexican authorities to drive out the American settlers was met by armed resistance, and the Bear Flag Revolt was on. The Bear Flaggers looked to Fremont for leadership. The USS *Portsmouth* landed a party of men in Monterey Bay and raised the U.S. flag over the Mexican capital of Alta California.

The Mexicans captured several Americans, and a search party caught up with them at Rancho Olompali in northern Marin County. Two of the missing men were rescued, and the Mexican party was driven off. Fremont chased them through San Rafael to Sausalito, where they escaped by boat. That was the only battle of the Bear Flag Revolt.

Two years later, California became a state in the Union.

John Reed was the first permanent settler in Marin County. As the owner of the 8,000-acre Rancho Corte de Madera del Presidio, he built an adobe home in what is now Mill Valley. On the nearby creek, he built a sawmill, which gave the town its name, and began clearing the vast forest on his property. His home is gone, but the mill has been restored in Old Mill Park.

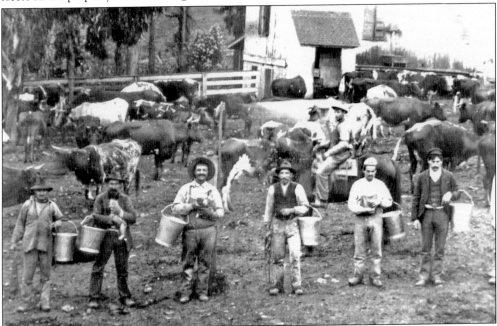

The first settlers in Marin County raised cattle and horses. The first cattle were raised for tallow and hides, not milk or meat. When the Mexican cattle were replaced by new breeds brought in from Britain, a dairy industry was born, and that industry has dominated Marin agriculture until today. Portuguese dairymen, mostly from the Azores, were also imported to work on the ranches.

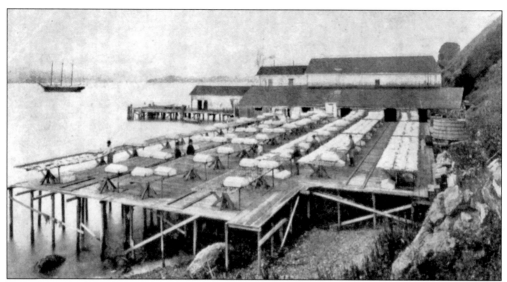

Another pioneer industry was cod fisheries. Huge schools of cod had been found in northern waters. Salted at sea, the fish were brought to Marin County, where they were washed and packed for shipment all over the country.

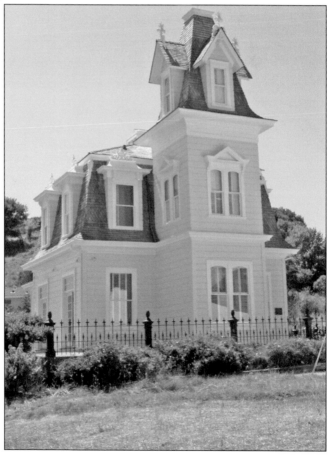

One of the oldest houses still surviving from the ranching era is the Lyford residence. Hilarita Reed Lyford was the daughter of John Reed. She inherited the Strawberry Peninsula, and after she married Dr. Benjamin Lyford, they established the Eagle Dairy where the Harbor Point Tennis Club is today. In 1957, when the house was threatened with destruction, it was moved across Richardson Bay to the Richardson Bay Audubon Sanctuary.

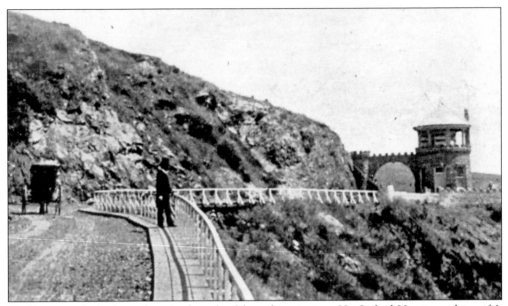

Dr. Benjamin Lyford was fanatic about health and sanitation. His Lyford Hygeia on his wife's other land at the end of the Tiburon Peninsula was envisioned to be "a great sanitarium, free from fogs and malaria." It was not a success, but the stone tower built as an entrance still guards Raccoon Strait.

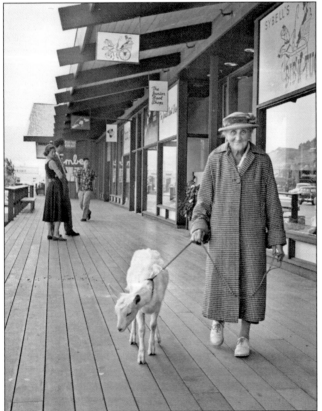

Rose Rodrigues Da Fonta arrived from the Azores as a young girl and worked as a maid in the Reed household, living in a run-down cottage on their ranch. John Reed's grandson gave the property to Rose, who later gave the valuable land to form the Richardson Bay Audubon Sanctuary. In her later years, Rose maintained a small herd of goats and was known as the Tiburon Goat Lady. She occasionally took one of her goats for a walk in town.

One of the original land grantees who retained a significant share of his property was Ignacio Pacheco, a wheat farmer. His descendants still live in the old Pacheco home in the part of Novato called Ignacio. Grapes were also grown in the area.

Many of the early ranchers in north Marin County are buried in the cemetery in Novato's Pioneer Park.

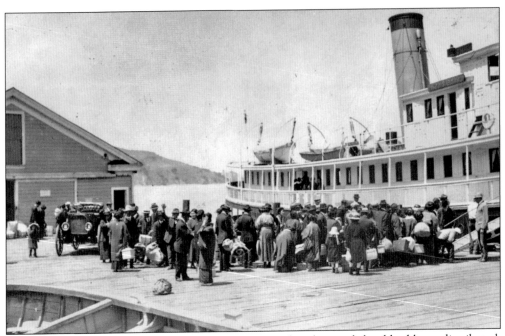

A great many Chinese came to Marin County years after the ranch land had been distributed. They were shrimp fishermen and workers on the railroads. The Gold Rush of 1849 brought even more. The Chinese Exclusion Act of 1882 barred the legal entry of laborers from China but allowed merchants, students, and teachers. Many workers already here settled on the San Pedro Peninsula at China Camp, now a state park.

Camilo Ynitia, a headman (equivalent to chief) of the Coast Miwok tribe, built an adobe house on his ranch at Olompali, the only land grant to a Native American. Camilo sold most of his land to James Black. In 1863, Black gave the ranch to his daughter upon her wedding to Dr. Galen Burdell, a San Francisco dentist.

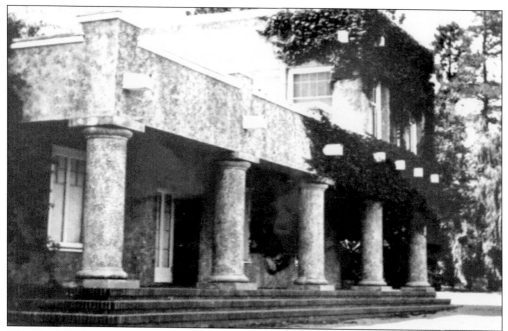

The Burdells built a 26-room mansion around the original adobe home on the property and surrounded it with elaborate gardens. It remained in the family until 1943, when it became a Jesuit retreat owned by the University of San Francisco. In the 1960s, the university leased it to various groups, including the rock band the Grateful Dead. The house was turned into a hippy commune and subsequently burned. Parts of the adobe house are still visible under the ruins of the Burdell mansion. The entire complex is awaiting funds for preservation.

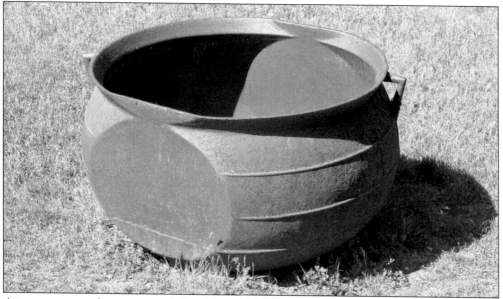

A try-pot was used to separate whale oil from blubber on the whaling ships that called in Marin County. This one ended up on the ranch of Camilo Ynitia in Rancho Olompali, where it was used to render tallow from cattle slaughtered for their hides. Hides and tallow were exported to Mexico for further processing, then shipped to the East Coast.

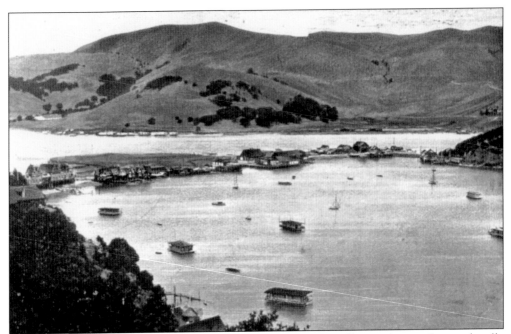

Some of the earliest residents were not landholders but lived on floating homes, known locally as arks, in the bays and coves of southern Marin County. Most were owned by wealthy San Franciscans who took refuge in them when their primary residences were destroyed in 1906 by the earthquake. They found that Marin was a great place to live and never left.

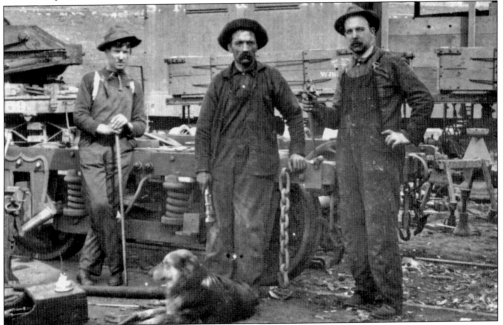

Another group of early arrivals were the Irish workers imported to build the railroads. They dug mile-long tunnels by hand and built enormous wood trestles to cross the swampy land along the shore of the San Francisco Bay. Many, such as these three working men, stayed on to work on the operating railroads after construction was complete.

Four

THE BAYSIDE VILLAGES

Most of Marin County's population lives in a series of cities and towns fronting on or near San Francisco Bay and sheltered by Mount Tamalpais. Getting goods and services to and from San Francisco was a goal of the early settlers, so the original towns grew up along the railroads.

Sausalito, Tiburon, and Belvedere are often compared to villages on the French or Italian Riviera, with the homes spilling down steep cliffs to waterfronts lined with cafés and yacht harbors. Further north, San Rafael was the site of the first mission and the county seat, and Novato remained largely undeveloped until after World War II. Nestled in huge redwood forests, Corte Madera, Larkspur, Ross, San Anselmo, and Fairfax follow Corte Madera Creek west through the Ross Valley. Mill Valley connects the San Francisco Bay to the steep slopes of Mount Tamalpais.

Marin County is a peninsula that contains several more peninsulas: Point Reyes, Tiburon San Pedro, and San Quentin. A Miwok warrior named Quintin was captured and executed by the Mexicans on the peninsula named after him. He was not a saint, but there was an early saint named Quentin, so the area became known as San Quentin.

Richardson Bay between Sausalito and the Tiburon Peninsula was the winter home of the north Pacific whaling fleet. They found fresh water to fill their tanks and plenty of firewood to provision their vessels for the long journeys to the whaling grounds.

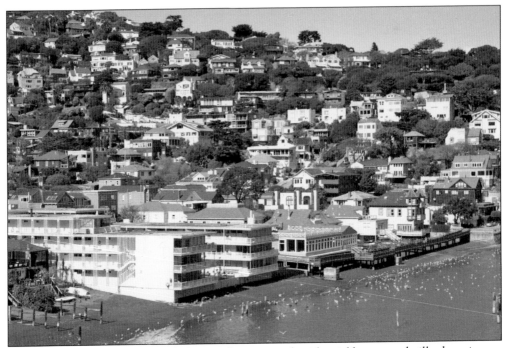

Sausalito, one of the earliest settled towns, has a mix of residential homes and villas hanging on the hillside intermingled with small leafy gardens. Sausalito's commercial stores, restaurants, and hotels are crowded with visitors and residents every day of the year. Cars, buses, and bicyclists pass by in an unending stream headed for San Francisco.

A small plaza in the center of Sausalito carries out its Mediterranean Riviera ambiance. An eclectic mix of characters roamed the waterfront during the 1960s and 1970s, making Sausalito world famous. Electing Sally Stanford, one of San Francisco's leading madams, mayor only lead to further fame.

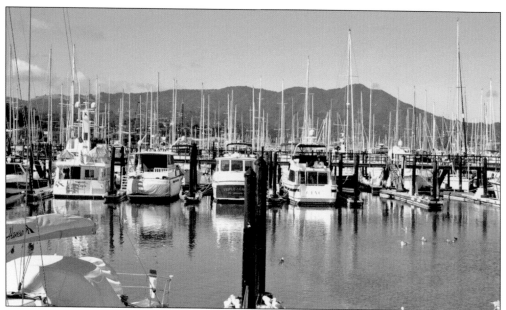

No other Marin County city is dominated by waterfront activity as much as Sausalito. Private yachts and public ferries, restaurants, marinas and boat repair yards, and providers of everything nautical can be found along the Sausalito shore of Richardson Bay. During World War II, 93 Liberty ships and tankers were built in Sausalito shipyards.

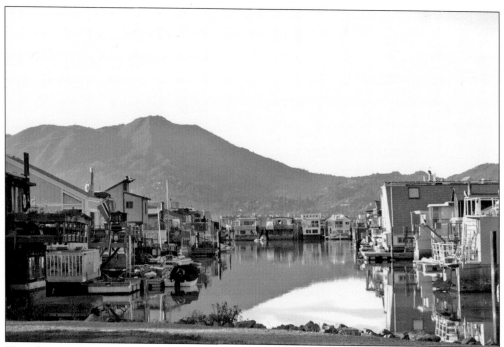

Houseboats, often striking and elegant, line the Sausalito waterfront. Most look simple but inside are stylish, and the relaxed lifestyle lures art lovers, artists, and writers who seek the sounds of birds, the water, and the sights. Living here is not simple or cheap in any way—it is expensive to rent or own a houseboat.

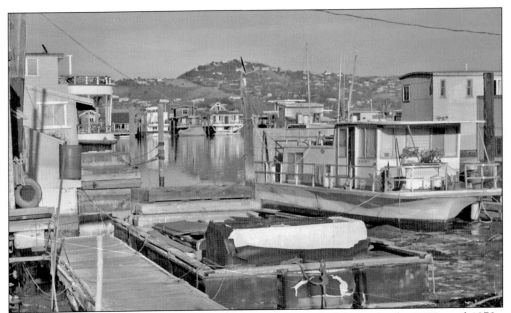

The original houseboat marinas in Sausalito were havens for hippies in the 1960s and 1970s. Today people who live in this attractive community frequently are commuters with active careers in San Francisco. Many are married couples with children.

The first port of call for visiting sailors from around the world is Sausalito. Once known as Whalers Cove, this Shangri-la for boat lovers was the winter haven for whalers of all nations. It is still filled with adventurers and sailors of all types.

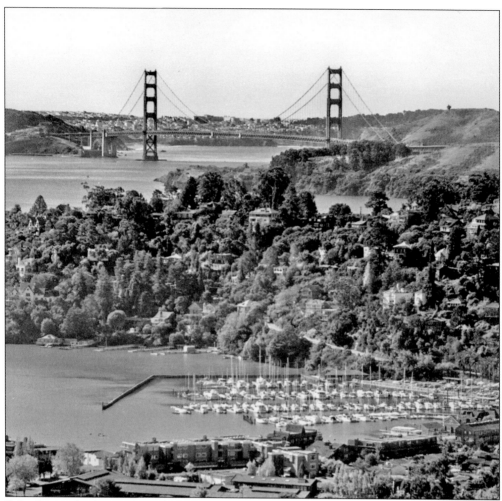

Belvedere and Tiburon share the Tiburon Peninsula and are typical of southern Marin County communities—homes with fabulous views, gardens and trees, yachts moored at their doorsteps, and either the Golden Gate Bridge or the San Francisco skyline in view.

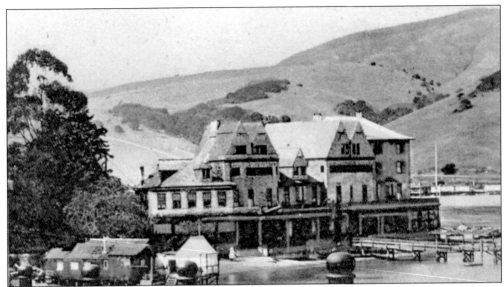

The Belvedere Hotel was a popular resort during the Gay Nineties, but because it was large and pretentious, it was torn down in 1925. Now the site is home to the recently remodeled San Francisco Yacht Club. The club welcomes visiting sailors and is the center of Belvedere's social life.

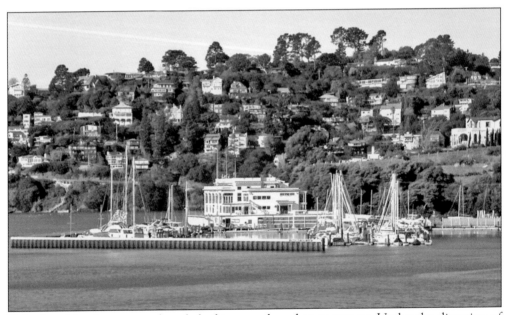

Belvedere Island was once denuded of trees and used as pasturage. Under the direction of the Belvedere Land Company, it was subdivided into lots and even had a golf course. In early years, most homes were built for summer or vacation use. San Franciscans who moved here after losing their homes in the 1906 earthquake found the commute bearable and stayed on as permanent residents.

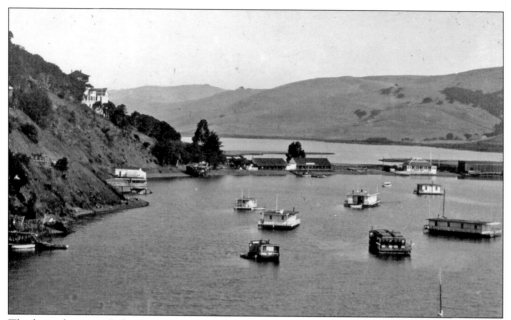

The houseboats in Belvedere Cove were called arks and were fancy party places for the popular crowd in the early 20th century. When the arks were moved to a more sheltered area during the stormy rains of the winter, a drawbridge on Main Street in Tiburon was opened to let them pass. This became the tradition of "Opening Day" on the San Francisco Bay.

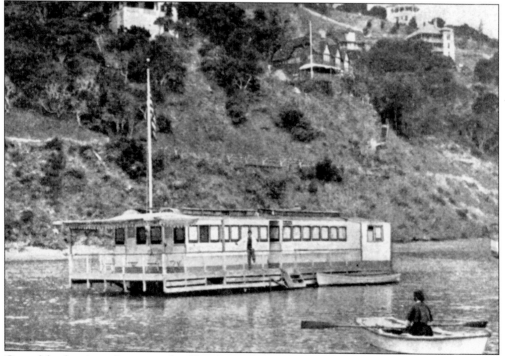

One of the fanciest arks was made of four horse-drawn San Francisco streetcars fastened together and placed on a barge. Many festivals were held in the summer months. "A Night In Venice" was a popular theme with the arks decorated with lanterns and revelers boating from ark to ark.

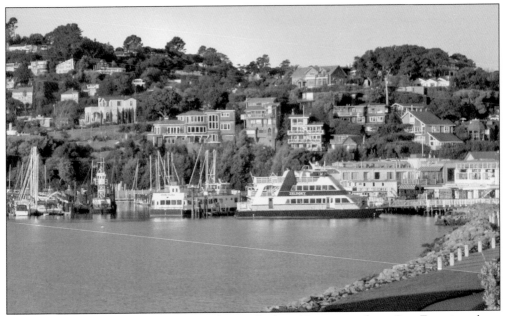

Tiburon, a former railroad town, can be reached in 18 minutes from San Francisco by a catamaran-type ferryboat. The boat is not only fast, but also safe and pleasant, and the sights are incomparable. Many Belvedere and Tiburon residents can walk to the ferry, but bicycles are becoming a popular alternative.

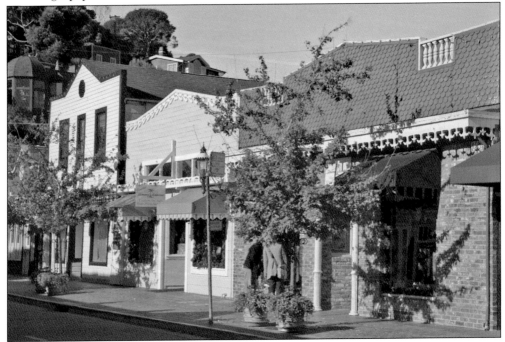

Tiburon's Main Street is only one or two blocks long, but it houses what most visitors want—excellent restaurants, unique shopping, one-of-a-kind architecture, and a few beauty boutiques. Many of its buildings date to the railroad era, and some are former arks raised up to street level in an area known as "Ark Row."

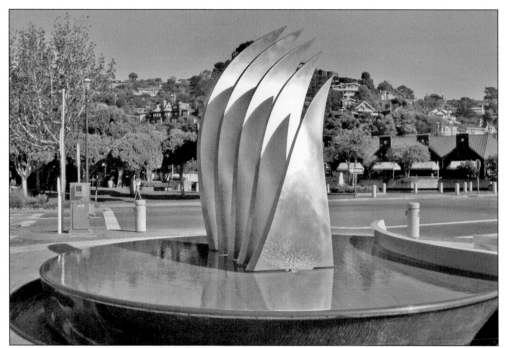

Coming About, the fountain in Tiburon's main plaza, is a charming enhancement to the small downtown, once the heart of railroading in Marin County. Locomotives, passenger cars, and ferryboats were built in the Northwestern Pacific yards, and passengers and freight between San Francisco and the north passed through the terminal in Tiburon.

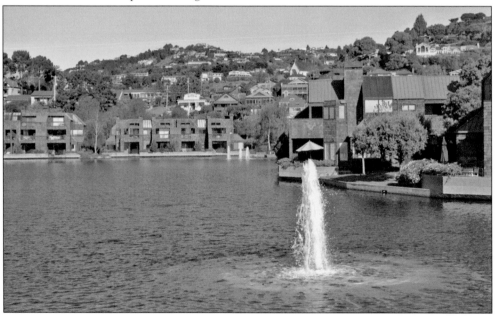

When the trains made their last runs in 1967, the downtown railroad yard became Point Tiburon, a posh condominium community. It has the San Francisco Bay, the San Francisco skyline, and the Golden Gate Bridge as its view. It is surrounded by beautiful homes on the hillsides, has a shoreline park and promenade, and is served by a high-speed ferry to San Francisco.

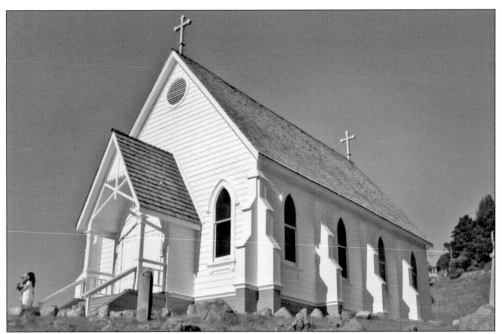

One of the oldest original churches in Marin County is Old St. Hilary's on a hill overlooking downtown Tiburon. Built to serve the ranchers and railroad workers of the 1880s and 1890s, the church is now a national landmark and a setting for weddings, concerts, and meetings. It is surrounded by an unusual natural garden of wild flowers.

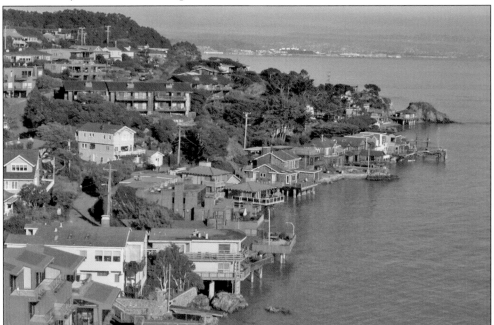

Tiburon's old townhouses in Lyford's Cove have become updated and glamorous, and have retained the artistry and creative architecture they started with in the town's earliest history. Located on Raccoon Strait across from Angel Island, the houses have a distant view of the hills of Berkeley and the University of California.

44

The downtown stores of Mill Valley are still in the same storybook settings—sometimes in the same buildings that housed the grocers, the blacksmiths, the locksmiths, and the clothing shops of the early 20th century. The artistry of the exteriors, combined with the giant redwoods that rise in the center of town, create a setting that is unique.

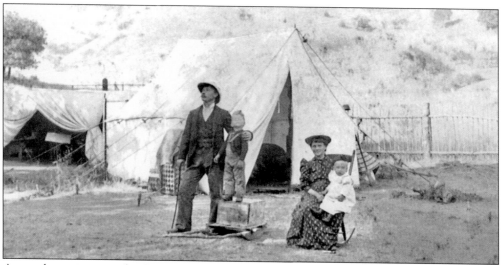

A popular activity in the Gay Nineties was hiking and camping on Mount Tam. Mill Valley was the jumping-off point for many of these activities, although some parties preferred to stay in town. Many small lots were sold to weekenders to set up their tents. On summer weekends, 3,000 or more visitors would pitch tents on their private lots and hold parties and dances. (Courtesy Marin History Museum.)

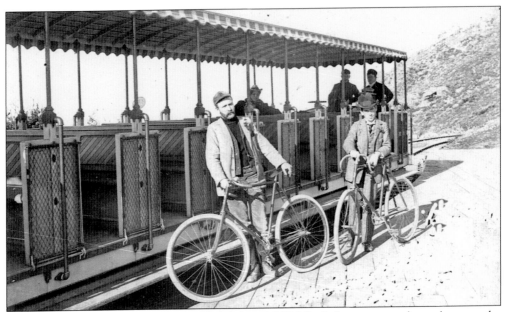

The "Crookedest Railroad in the World" left from Mill Valley's downtown and ran almost to the top of Mount Tam. For those brave enough, a ride down in a "gravity car," whose descent was powered by gravity, was an added thrill. A fire in 1929 burned the tracks, and the railroad was abandoned the next year. (Courtesy Marin History Museum.)

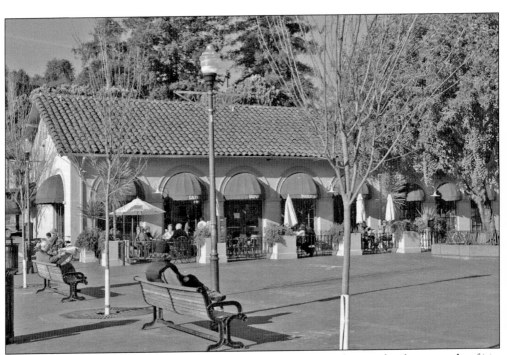

The former Northwestern Pacific commuter railroad depot combines a bookstore and café in a charming building and plaza. It is a beautiful and comfortable place to relax for breakfast or lunch and catch up on local gossip.

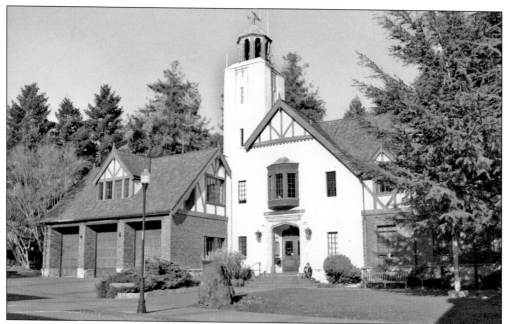

In Mill Valley, even the city hall and firehouse are artistic. In 1890, the Tamalpais Land and Water Company sold 200 lots in one day, advertising "All the attractions of country life, plus all the advantages of city life, minus the discomforts of each." The company changed the name to Eastland, but the city incorporated as Mill Valley in 1900.

Standing at 231-3 Blithedale, Mill Valley, is an ideally located apartment house. It is also one of Mill Valley's oldest buildings and was one of the early bawdy places on the edge of town, a place for drinking and "those of questionable reputation."

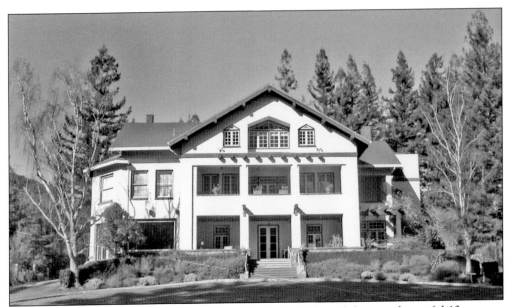

Ralston White, one of Mill Valley's earliest land barons, selected the most beautiful 13 acres as the setting for his house. He and his bride hosted their neighbors and friends for the next 60 years. The large and spacious grounds are the setting for a conference center today.

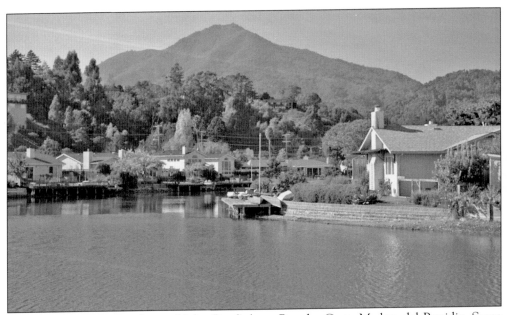

Corte Madera was carved out of John Reed's huge Rancho Corte Madera del Presidio. Some waterfront homes on the east side of Highway 101 have direct access to the San Francisco Bay. The beautiful lagoon pictured here provides some homes on the west side of the highway with a tropical setting and great views of Mount Tam. Paired with Larkspur, the two are known as the "Twin Cities."

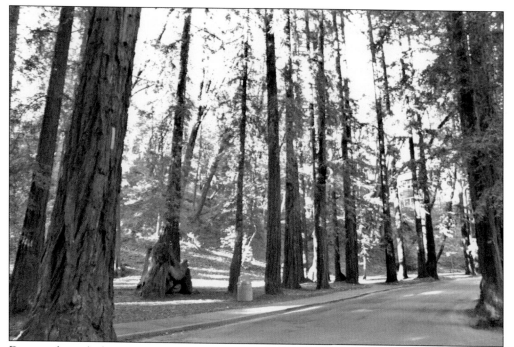

Driving through the Twin Cities' beloved canyons on a gorgeous day is a memorable experience. Corte Madera's Town Park has one of the largest level playing fields in the otherwise hilly county and is the site of community festivities. Most of the shopping malls in southern Marin County are located in Corte Madera and Larkspur.

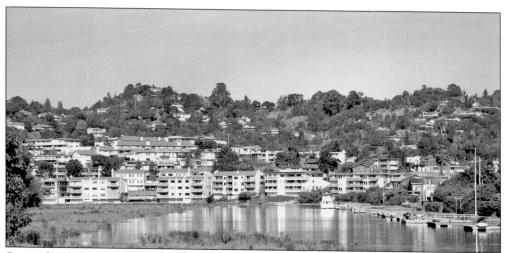

Some of Larkspur's condominiums are located on Corte Madera Creek, once the main waterway to Marin County's agricultural heart. Ross Landing was the busiest shipping point in the state, but the cutting of the forests led to filling in the watershed and diminished commercial use of the creek.

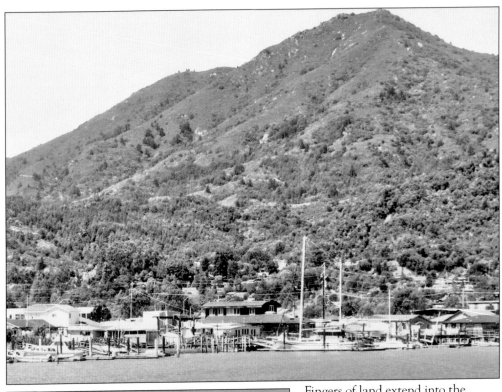

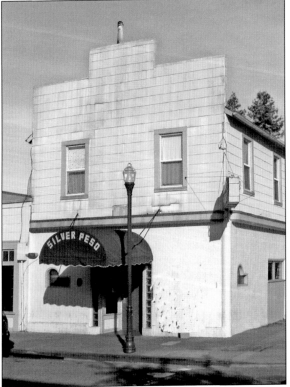

Fingers of land extend into the San Francisco Bay at the mouth of Corte Madera Creek, creating the Greenbrae Boardwalk, an ideal place for those who enjoy living with the sounds of the gulls, foghorns, and the sea. Larkspur was once known as a sporting town—a big picnic ground famous for its saloons, bowling alleys, and prize fights. It was a playground of the fun-seeking middle class.

One of Larkspur's oldest buildings was first a black smithy, then Carl's Market. During the Rosebowl era, it was Bob's Tavern, a popular stop between the railroad station and the outdoor dance pavilion. Later a World War II ex-GI heard the story of the Philippine government dumping its national bank reserves into Manila Bay to prevent them from falling to the Japanese. He put together a dive team and recovered enough silver pesos to come back and buy the tavern, renaming it the Silver Peso.

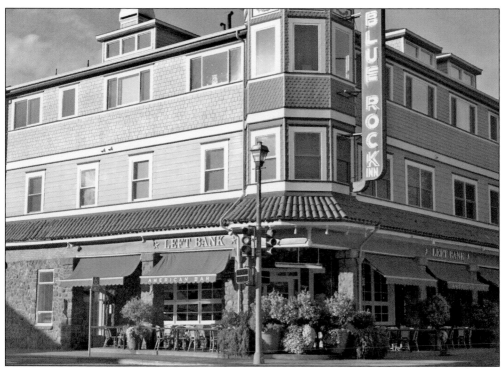

The Blue Rock Inn was built on the main stage route in 1895. In the railroad era, Larkspur was one of the most popular destinations in Marin County. Five thousand patrons would come to the Rosebowl on weekend evenings to dance and picnic under the stars. The Blue Rock Inn was also home to the largest restaurant in the area. During Prohibition, it was one of 21 speakeasies operating in Larkspur.

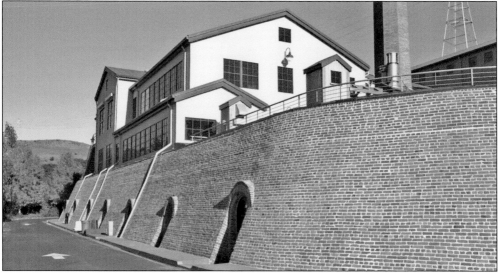

The Remillard brick kiln was busy more than 100 years ago. Four company schooners carried 500,000 bricks a year all over Northern California. Here the bricks were made to rebuild San Francisco after the 1906 earthquake destroyed much of the city. A much-revered landmark, it has been rebuilt as a restaurant/office complex and is listed on the National Register of Historic Places.

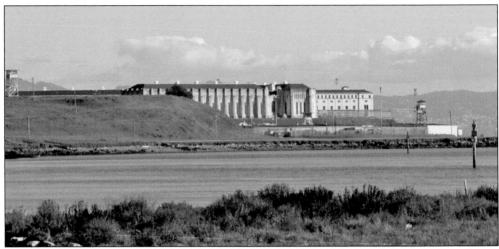

The land for San Quentin Prison was purchased for $10,000 in 1852. Built to house 156 prisoners, it had 300 when it opened. Overcrowding continues to be a problem. Almost 6,000 prisoners are held there now, double the design capacity. In 2006, there were 560 inmates on death row alone. In former days, Friday was hanging day, and a gallows in the courtyard helped alleviate the overcrowding problem.

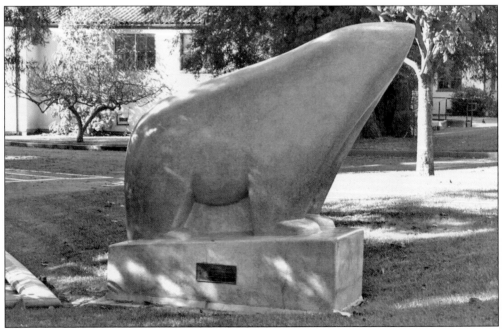

In Ross, a beloved sculptured bear created by Beniamino Bufano stands guard at the entrance to the Ross Town Hall on Sir Francis Drake Boulevard, a winding tree-framed road leading to the sea at Point Reyes. It was planned to be the freeway to west Marin County, but a revolt by Marin's citizens halted that idea. It is still the only east-west, bay-to-Pacific road in Marin.

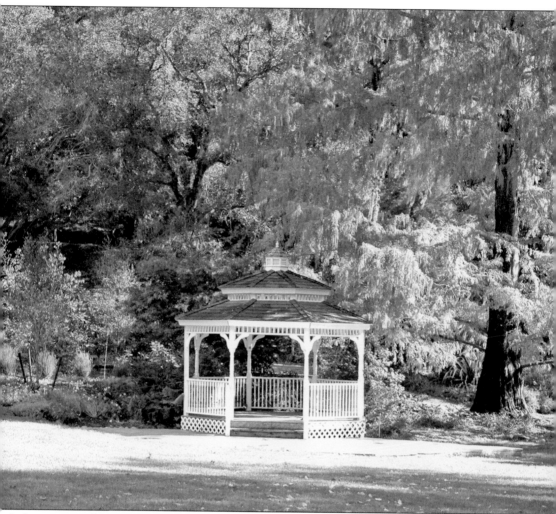

A charming gazebo accents the surroundings in the Marin Art and Garden Center in Ross. James Ross bought most of the Ross Valley from Juan Cooper, the original grantee. One of many estates located on Ross's property was Sunnyside, built by his daughter Ann and her husband. In 1946, eight and one half acres of their land were acquired to be the art and garden center.

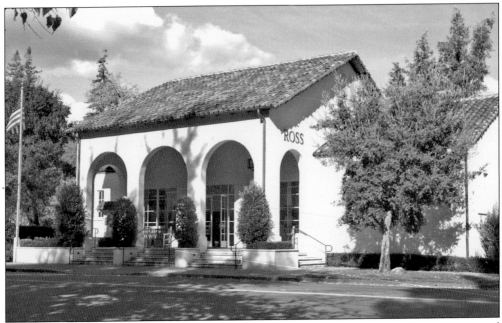

The Ross Post Office is a pleasant location for locals to learn about news, coming events, and enjoy a little camaraderie. The town of Ross and unincorporated Kentfield and Kent Woodlands contain some of the most expensive homes in Marin County. William Kent donated the land for Muir Woods and much of the Mount Tamalpais State Park.

San Anselmo is blessed with tree-framed streets and sun-kissed winding hills. Off to the right is the English Tudor-style Church of St. Anselm, and higher on the hill is a glimpse of the San Francisco Theological Seminary campus. This was the hub of the rail network throughout Marin County. Standard and narrow-gauged tracks met here, and a spur to San Rafael connected Marin's largest city to the system.

Heading west on Sir Francis Drake Boulevard, the road leads into Fairfax, named for Charles Snowden Fairfax. Heir to the title of Lord Fairfax, he never accepted the title because he would have had to give up his American citizenship. His friends did call him "Lord" in jest, and his wife was always pleased to be referred to as Lady Fairfax. His estate, Bird's Nest Glen, became the Marin Town and Country Club in the heyday of the big bands. These signs typify the Fairfax of today: ultra liberal and environmentally active.

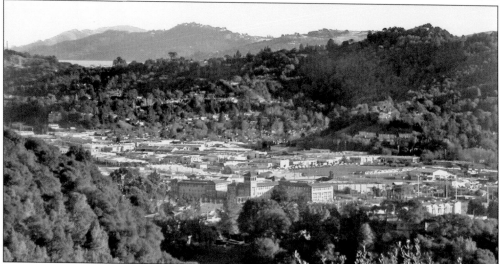

The first mission north of San Francisco was established in San Rafael in 1817, and it has been the county seat ever since. First the padres ruled it with an iron hand. After Timothy Murphy was given 21,680 acres by the Mexican government, he ruled as the landowner and as county administrator.

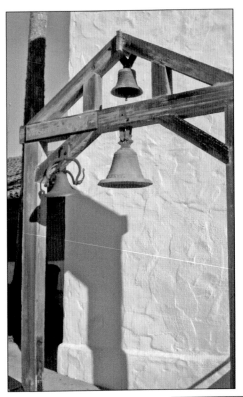

The three treasured bells of the Mission San Rafael Archangel were rung to signify the end of the workday or the beginning of mass since the 1820s. These original bells have been replicated and placed in a mission museum. The duplicates were hung in the mission. The Coast Miwok tribe members who lived at the mission were virtual slaves. Most were baptized and married at the mission, and many were buried in the churchyard.

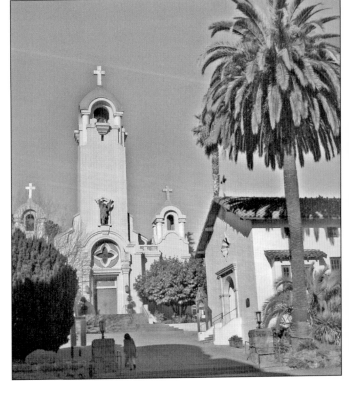

The original mission church did not survive the ravages of time, but a new and larger Saint Rafael's Church was built in 1870 to replace it on the land donated by Timothy Murphy. In 1917, this church burned. In 1919, it was replaced by a church, a convent, and a school.

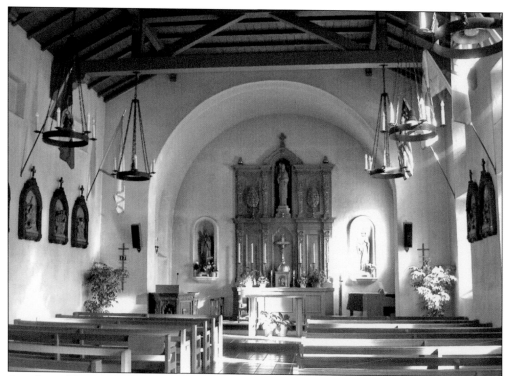

A replica of the original mission was added in 1949. The architects used sketches drawn by Gen. Mariano Vallejo to try to visualize what the original mission had looked like.

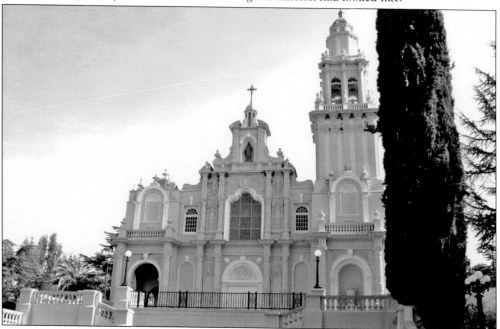

St. Vincent's Orphanage dates from the early 1800s, when the original grantee, Timothy Murphy, gave a large portion to the friars of St. Vincent. It was the friars who built this treasure of a building, destined to be a landmark admired for its stunning architecture.

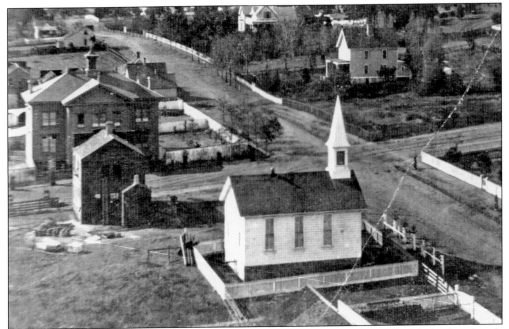

The corner of Fifth and B Streets in San Rafael was less crowded in 1866. The Methodist church did not leave much room for expansion. (Courtesy Marin History Museum.)

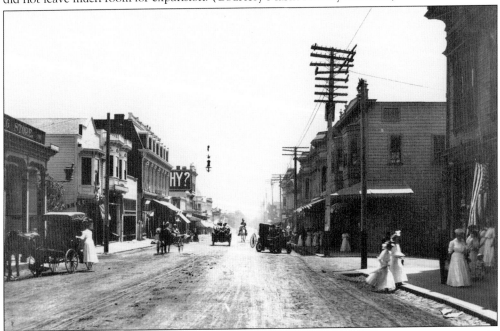

Fourth Street in San Rafael was just beginning to appear like the main street in a county seat in 1905. The scene here is looking east from D Street. San Rafael was settled by Timothy Murphy from Dublin, Ireland. He was a big man and ruled central Marin County for decades. He never married and distributed his huge estate to several relatives, including a nephew named Lucas who developed Lucas Valley. Murphy was the county administrator and was called Don Timoteo by the Californios. (Courtesy Marin History Museum.)

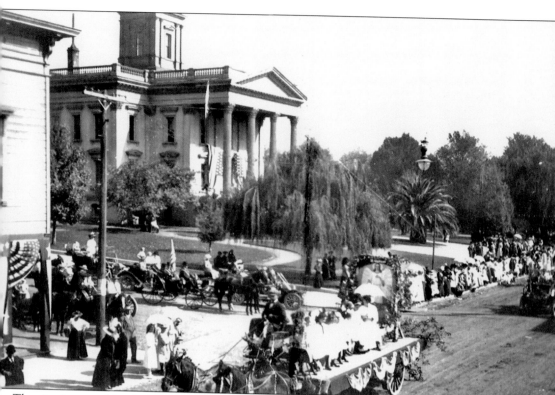

The viewing stand for the Fourth of July parades was in front of the old county court house built in 1872 to house the county courts, the administrative offices, and the board of supervisors. It was destroyed by a fire in 1971, shortly after the opening of the new Frank Lloyd Wright–designed civic center in Terra Linda. (Courtesy Marin History Museum.)

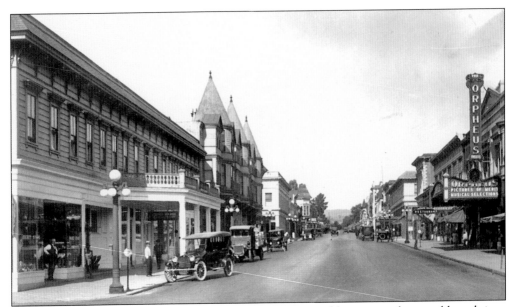

By 1920, Fourth Street was getting the department stores and businesses that would mark it as Marin County's premier place to shop—that is until the giant malls were built. The early malls appeared in the outskirts of San Rafael. (Courtesy Marin History Museum.)

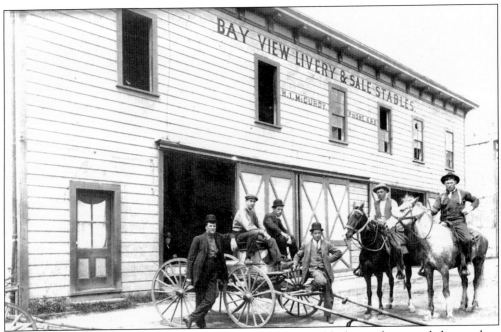

One of the primary businesses in old San Rafael was taking care of the horses that provided so much to the population. Bayview Livery was a popular gathering spot for the young gentlemen of the era. The hats distinguished the cowboys from the business men. (Courtesy Marin History Museum.)

Where San Rafael Creek empties into San Rafael Bay it becomes known locally as the "Canal." The shores are lined with boatyards, many containing luxury yachts. Some are real working boatyards where extensive repairs or complete overhauls are possible. A Latin American atmosphere pervades the canal district as it attracts new arrivals from Mexico and Central America.

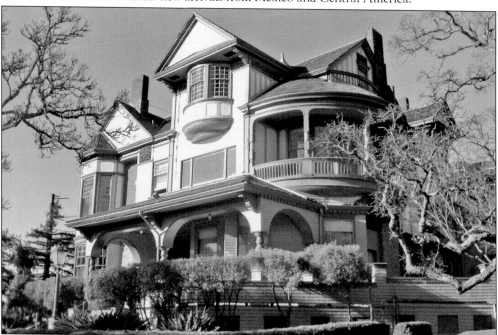

This house was built in the early 20th century by Capt. Robert Dollar, whose legendary fortune was from the Dollar Line, the largest steamship company on the West Coast. His mansion was named Falkirk after his home city in Scotland and was the centerpiece for festive parties. Captain Dollar was one of Marin County's early benefactors. Falkirk is now owned by the city of San Rafael and used for a variety of functions.

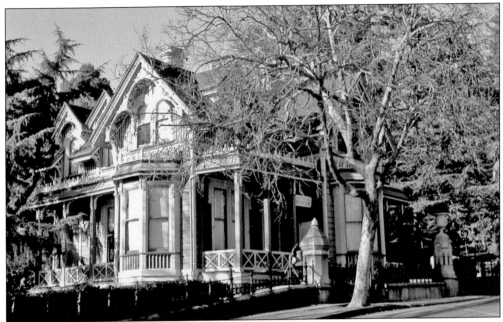

In 1905, John and Louise Boyd donated their mansion and 17.5 acres of gardens to the city of San Rafael in memory of their two sons. In 1920, their only daughter, Louise, became the heiress to the Boyd estate. She traveled to the Arctic and Asia and provided funds for many scientific voyages of exploration; however, some investments went awry financially, and she died bereft of her fortune. Since 1935, the gatehouse has been the home of the Marin History Museum.

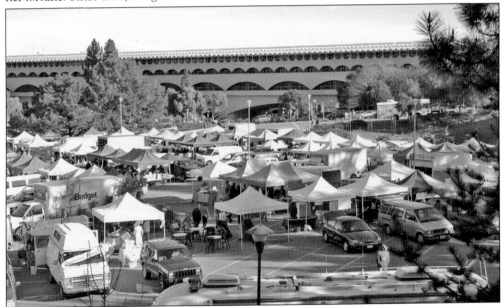

The outdoor Farmers Market is held on the Marin County Civic Center grounds on Sundays. It is a place where the local farmers gather to show off their beautiful, homegrown vegetables, fruits, and flowers, many produced organically and pesticide-free. The people of Marin County are in the forefront of the organic food movement. Ranches produce milk and cream to make organic cheeses and beef and lamb.

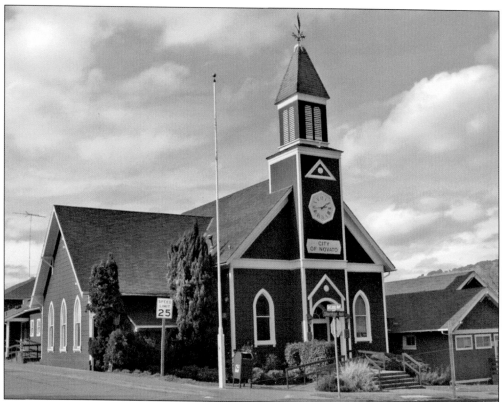

The city of Novato used a charming old church building as the city hall during the 1950s. While the building is inadequate by today's standards and would be expensive to rebuild and enlarge, the question of moving city hall to an entirely new location is controversial. The building will be preserved in any case.

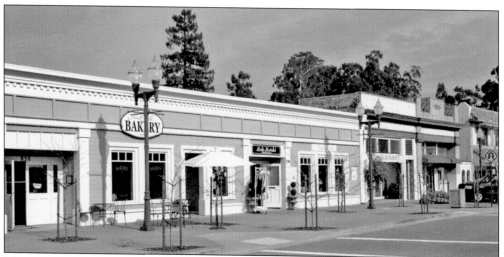

Novato is the second largest city in Marin County with more than 50,000 residents; most of them arrived after World War II. Vast tracts of new homes and huge new shopping centers sprang up around the small core of "Old Town" where small shops keep the old look from being lost completely.

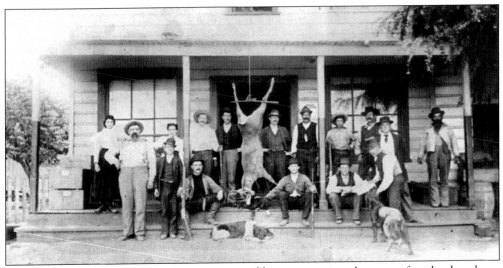

The wide-open spaces of Marin County attracted hunting parties who went after the deer, bear, and elk roaming the hills. These hunters gathered at a store in Novato to display their trophies and socialize. (Courtesy Marin History Museum.)

Several small unincorporated villages lie between Fairfax and the Pacific Coast. Woodacre was an important stagecoach stop and a popular railroad destination for Bay-area picnickers in the 1890s and well into the early 20th century. But it was a little too far out for commuters, even though there was excellent rail service to the ferries.

Five

ALONG THE
PACIFIC COAST

The blunt southern end of Marin County is the most visible segment of the Pacific Coast. As the north side of the Golden Gate, every ship entering or leaving San Francisco Bay passes its steep cliffs and rocky shores that make any direct approach by land or sea a dangerous proposition. Every northbound car crossing the Golden Gate Bridge enters the county through the Marin Headlands.

A century of military fortifications ranged from Civil War–era muzzleloaders to 16-inch naval rifles embedded in massive concrete bunkers during World War II. The Marin Headlands are laced with the roads and tunnels built to service these fortifications. Those trails are now used by hikers, bicyclists, and equestrians. The buildings to house the troops remain and now house art centers, conference facilities, and marine mammal rescue services. The reuse of these former military bases has been a primary function of the Golden Gate National Recreation Area (GGNRA), the federal landlord of much of southern Marin County's Pacific coastline.

Further to the north, the Point Reyes National Seashore takes over the conservation duties. Custodian of thousands of acres of dairy ranches and miles of scenic coastline, preservation of the ecosystem was the reason for this first seashore in the national park system.

Between the two huge parks are several coastal villages. Some, as in eastern Marin County, were built as second home locations for city dwellers seeking a hideaway. Others were the main stop on the early railroads where agricultural products were shipped to market and holiday seekers flooded in on weekends. The railroads are gone, and permanent residents occupy many of the homes. Victorian-era campsites have given way to small hotels and bed-and-breakfast inns.

Outside of the federal and state parks, the Marin Agricultural Land Trust has preserved 38,000 acres of family ranches by buying the development rights. The owners can continue ranching and pass the land to heirs but cannot subdivide the property.

The Pacific Coast of Marin County provides more than 100,000 acres of forests, ranches, and seashores for the enjoyments of residents and the more than 14 million visitors who come each year.

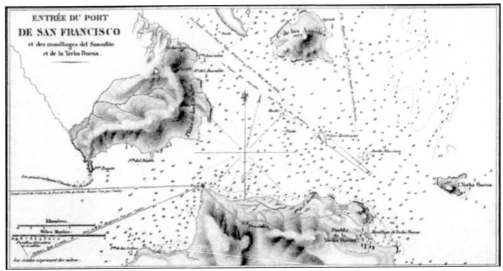

An early chart of the entrance to San Francisco Bay detailed the hazard of the Golden Gate. The Marin Headlands, Angel Island, and a bit of Belvedere can be clearly seen. For 200 years, pirates, explorers, and merchants missed this gateway to one of the great harbors of the world due to the fog banks that concealed it.

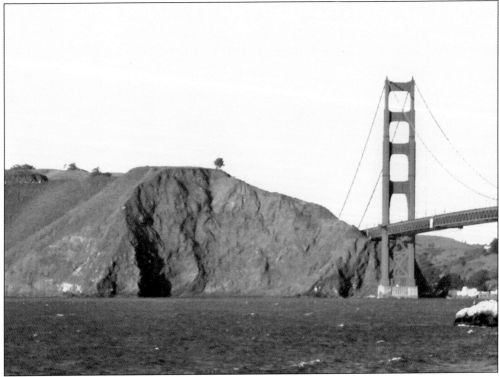

Rather than a large fort like Fort Point on the south side, the Marin side of the Golden Gate was riddled with hidden tunnels and bunkers to support coastal defense artillery. Tricky winds and trickier tides frustrated mariners who tried to enter San Francisco Bay in the days of sailing.

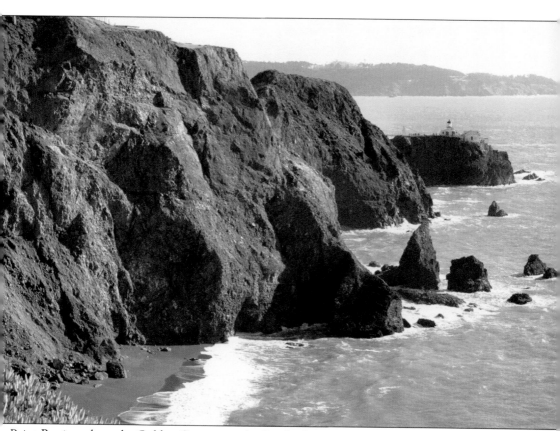

Point Bonita, where the Golden Gate meets the Pacific Ocean, was an exceptionally dangerous spot for navigators before the days of radar and GPS locators. Rather than tall towers, Marin's lighthouses were built close to the water, like the Point Bonita Light, so the light would be visible under the fog. They also depended upon fog horns and bells to warn mariners of danger.

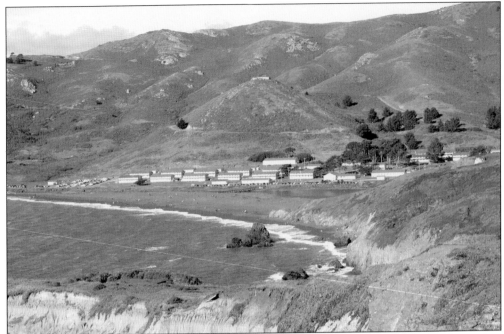

The buildings of the former Fort Cronkhite are highly useful. The Marin Mammal Center has rehabilitated 10,000 animals since opening in 1975 and is visited by 35,000 students each year to watch large marine mammals recuperate. Hundreds of seals, sea lions, otters, and other sea creatures that have been injured or have mysterious illnesses are brought to the center. A group of artists work in studios, and a detached group of buildings were converted to the Point Bonita Conference Center by the San Francisco YMCA.

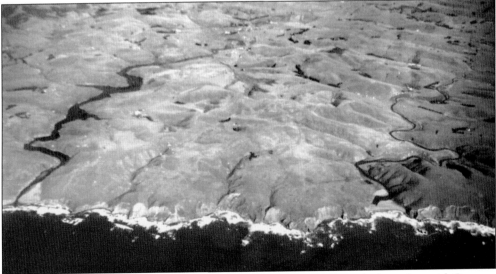

The Estero Americano, on the left side in this aerial photograph, forms the boundary with Sonoma County. The estuary to the right is Estero San Antonio, also known locally as Stemple Creek. The land between is typical of many coastal properties. The original settlers cleared the land and planted potatoes, onions, and other vegetables until the land gave out. They then raised cattle for several generations and finally sheep.

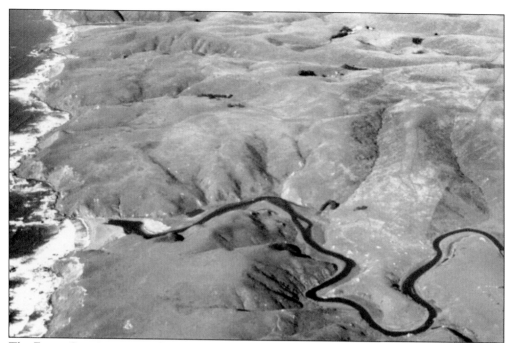

The Estero San Antonio snakes through the northwest corner of Marin County. The ranchers along its banks raised cows for milking until new health regulations forced them out of business. They converted to raising beef cattle until the market for beef dropped. Then they raised lambs for market.

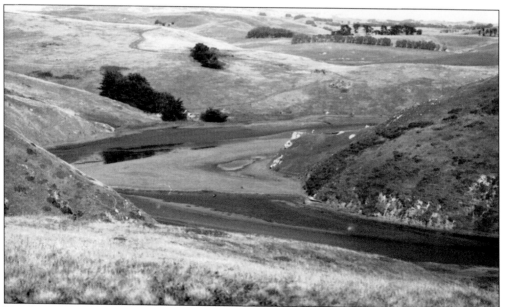

North Marin County's *esteros* (estuaries) are subject to tidal action in the rainy season, when the water flow is strong enough to clear the Pacific entrance that fills with sand during the dry season. Like most of Marin County, there are two seasons, green and brown. The Miwoks used fire in the brown season to chase game and to replenish the soil. When air quality standards permit, the ranchers do the same to control invasive weeds.

A family heads for an outing on a secluded beach along the north Marin County coast. Most of Marin's beaches are public property and are available for outings. The water is a bit chilly, and the presence of great white sharks dampens the enthusiasm for water sports, but there are always surfers, scuba divers, and abalone hunters who defy the dangers.

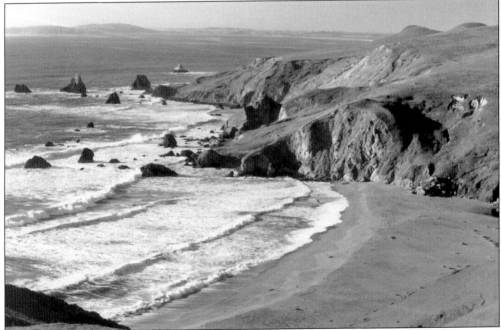

Some of the most spectacular scenery in the world will be found along Marin County's Pacific coast. Travelers compare it with the Amalfi Drive in Italy or the cliffs of the Irish coast. Advertisers find it irresistible as a setting for showing off new-model automobiles or high-fashion clothes.

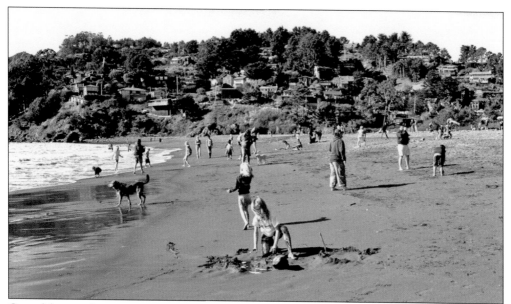

One of the popular recreation areas is Muir Beach where Redwood Creek enters the Pacific Ocean. Redwood Creek is fed by several smaller creeks flowing down the sides of Mount Tam and joining in Muir Woods. Just before entering the Pacific, Redwood Creek is joined by Green Gulch Creek.

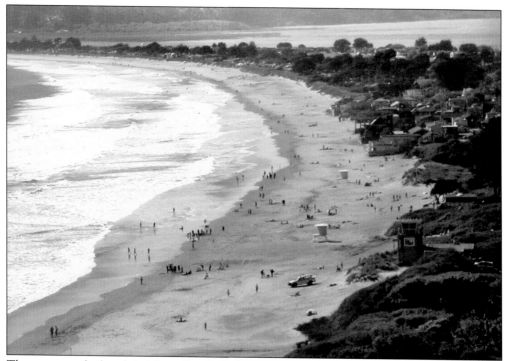

The most popular beach in Marin County is Stinson Beach. It is closest to San Francisco, and the weather is usually excellent. When the surf is up, it will be crowded with people riding the boards, but that can be dangerous for those who aren't careful. Great white sharks often linger just outside the surf line, but sunbathers keep an eye out for warning signals when sharks are spotted.

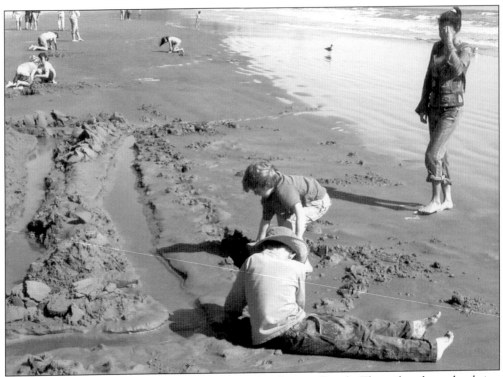

These young engineers are laying out a new canal at Stinson Beach. The railroads used to bring thousand of sun seekers to west Marin County every summer weekend. It was then a long hike to Willow Camp, as Stinson Beach was first called. In the 1850s, a county road was built from Sausalito to Bolinas, and by 1879, there were 20 family tents on the beach, plus changing tents for men and women.

Generations of families gathered at their favorite beach, or groups of friends would buy adjoining lots so that they could party together. At one time, a small plot of land for a tent or cabin could be purchased for a few hundred dollars. There are now enough private residences around Stinson Beach that a limited commercial district can survive. Between retirees and telecommuters, the year-round population continues to grow.

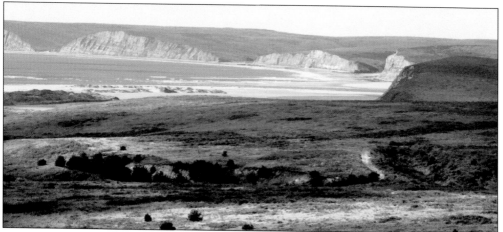

The broad sweep of the Pacific Coast where Francis Drake took refuge and repaired his ship is part of the Point Reyes Peninsula. The white cliffs reminded him so much of his homeland that he named this area "New Albion." A Spanish explorer first sighted it on the feast day of the Three Kings, "Tres Reyes," giving it the name used today. Traces of Drake's landing or the fort he built to protect his cargo of looted Spanish gold have never been found, leading to controversy over the exact location.

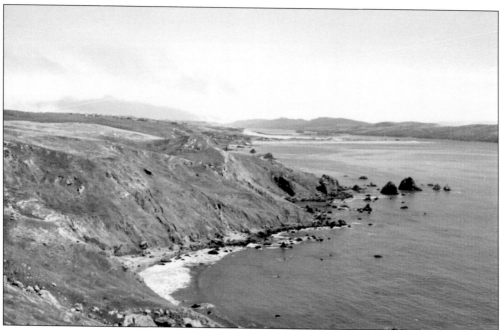

Spectacular to look at, but deadly to coastal shipping, Marin County's Pacific shore provided few havens of refuge to early mariners. More than 100 vessels have foundered along these shores. The Point Reyes Lifesaving Station was busy in the days before radar and other navigational aids.

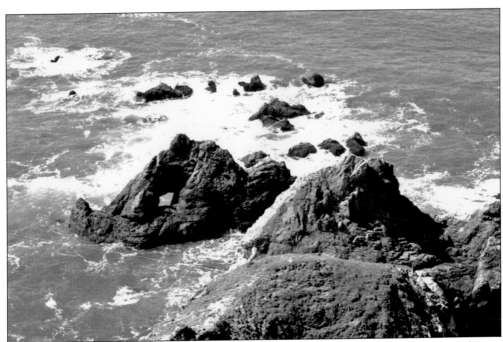

The relentless pounding of the surf has carved coastal rocks into fantastic and unusual shapes. The rocky outcrop where Point Reyes juts out into the Pacific is the place to watch the thousands of gray whales migrating south to calving grounds in the lagoons of Baja.

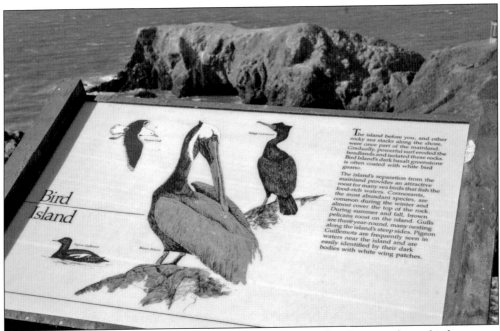

Bird Island's separation, small as it might be, provides an isolated setting for seabirds to nest, safe from terrestrial predators. During some seasons, the island is barely visible because of the number of birds.

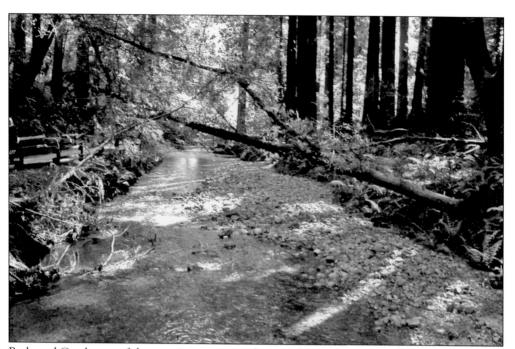

Redwood Creek, one of the remaining streams draining Mount Tam, runs through Muir Woods. It is typical of the water flowing through the giant redwood forests that greeted the early settlers. These settlers were building houses, barns, and cities, and Marin County's redwood forests provided the lumber.

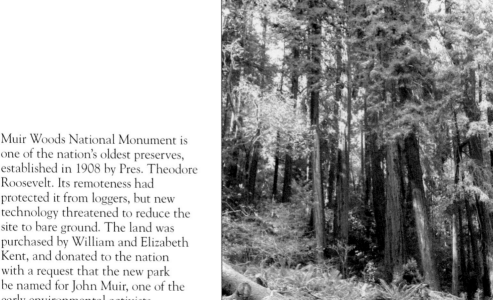

Muir Woods National Monument is one of the nation's oldest preserves, established in 1908 by Pres. Theodore Roosevelt. Its remoteness had protected it from loggers, but new technology threatened to reduce the site to bare ground. The land was purchased by William and Elizabeth Kent, and donated to the nation with a request that the new park be named for John Muir, one of the early environmental activists.

Muir Woods is the only large stand of ancient redwoods in the Bay Area. Visitors cross Redwood Creek as it makes its way to the Pacific Ocean at Muir Beach. Mature redwoods stand among young seedlings, standing snags, downed logs, and a community of understory plants—all the elements of an old-growth forest.

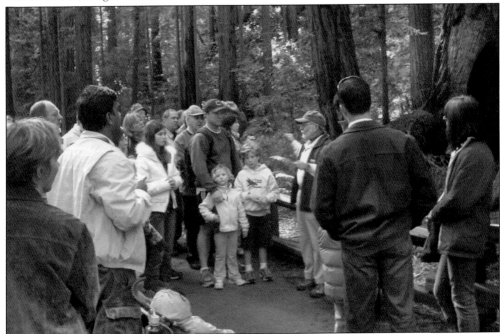

A park naturalist leads a party of visitors through the woods. They will visit the Cathedral Grove, a natural nave of giant redwoods that create a spiritual feeling. The park guides explain how these trees have survived for centuries. During the San Francisco meetings to found the United Nations, a special session was held in Muir Woods to honor Franklin D. Roosevelt, who had just died.

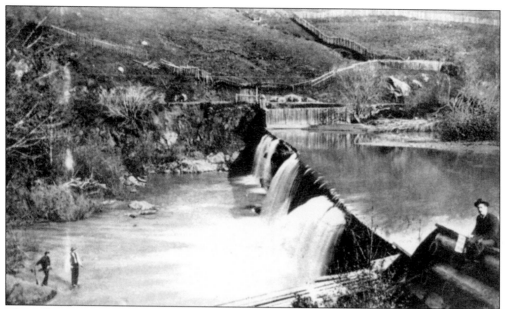

The 2,576-acre Samuel P. Taylor State Park follows the small creek where, in 1856, Taylor built the first paper mill on the West Coast. Taylor felt that Northern California needed decent paper for its newsprint and for its documents, so he acquired a tract of forest in west Marin County and a contract to buy the rags accumulating in San Francisco. To power his mill, Taylor built a dam across the portion of Lagunitas Creek that would eventually be called Paper Mill Creek.

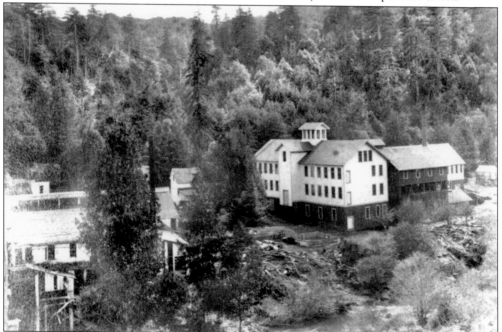

With the railroad passing his door, Samuel P. Taylor was able to ship his paper to many markets. But it also opened up an opportunity to build a campground and, eventually, a hotel. After his death, the family lost the property. The new owners sold it to the state for the unpaid taxes that had accumulated. (Courtesy Marin History Museum.)

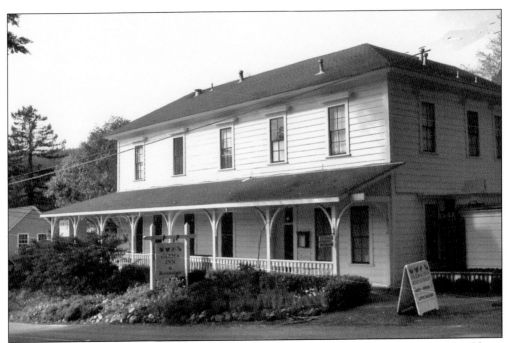

The crossroads town of Olema can trace it origins to the Olema tribe of Coast Miwoks. The Olema Inn has seen much of Marin County's history since it was built in 1876. The 1906 earthquake had its epicenter just down the road, and several major fires have threatened it, but the inn has survived them all. Most of Marin's buildings were made of wood and survived the quake.

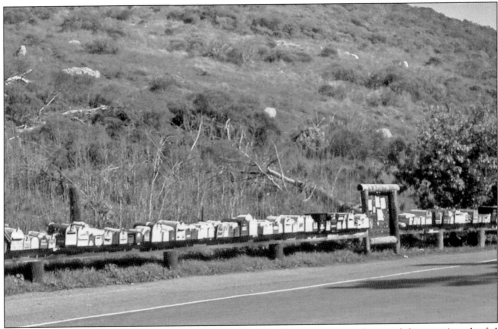

The mail must go through, but in West Marin, this does not mean home delivery. A colorful array of rural mail boxes line the Shoreline Highway near Muir Beach and act as a gathering spot for residents to share local news.

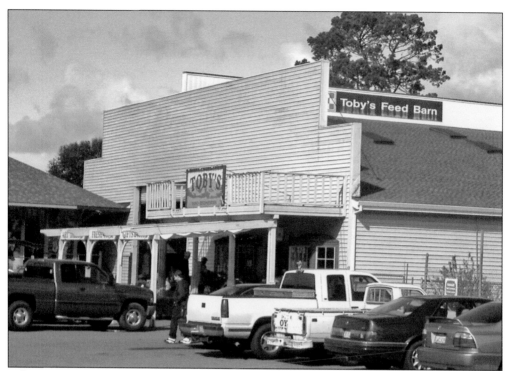

Toby's Feed Barn is a local institution in Point Reyes Station. This is still ranch country, and the necessary equipment and supplies for the care and feeding of horses, cattle, and sheep, and their owners are kept close at hand at the barn.

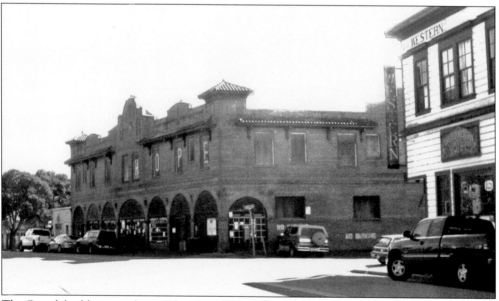

The Grandi building was the social center of West Marin for decades. The bandstand and beautiful dance floor attracted partygoers from all over the Bay Area. The 24 hotel rooms and the restaurant were filled every weekend. Even though the brick building survived the 1906 earthquake, modern building codes have kept it closed for decades.

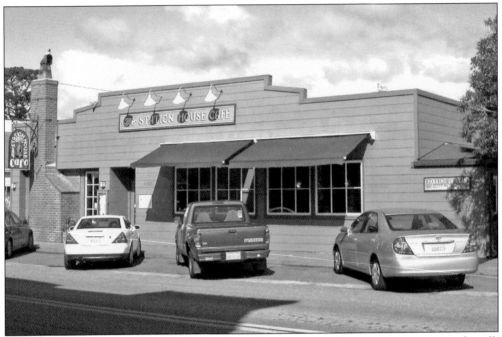

The Station House Café keeps alive the railroading traditions of Point Reyes Station—after all, that is how the town got its name.

The land grant that included Stinson Beach and a Miwok village known as Bauli-N—today's small, oceanfront enclave of Bolinas—was once the commercial hub of Marin County. Traces of the hippy movement of the 1960s and 1970s still exist. Finding Bolinas can be somewhat of an adventure, as locals tear down direction signs as fast as authorities erect them. This only adds to the mystique of Bolinas. Wharf Road, its one main street, is jammed with tourists every weekend.

Six

CULTURAL MARIN

Located in the midst of a large metropolitan area with great universities, world-renowned symphonies, opera, and ballet companies, and visiting artists of all persuasions, Marin County's resident are able to pursue a wide variety of cultural interests. Marin's contribution to this mix is not inconsiderable. The Marin Symphony Orchestra is one of the finest regional orchestras in the land. The Mountain Theater, high on Mount Tamalpais, draws visitors from throughout the Bay Area for its summer season.

Before there was a Hollywood and before New York had a film industry, Sun Valley in San Rafael was the center of film production in the United States. Silent-film classics were produced in greenhouse-like studios using daylight. Going full circle, Marin County is now the home of the most technologically advanced film production. Lucas Arts has produced the Star Wars and Raiders of the Lost Ark series here. The Pixar and Industrial Light and Magic studios have their roots in Marin. At the Academy Awards ceremony each year, there is a parade of Marin winners, mostly in the technical field, but occasionally, it is a local performer.

The College of Marin has two campuses and provides the stepping-stone for local students who go on to the University of California system after two years. Dominican University, established a century ago by Dominican sisters, is now a four-year, non-sectarian school. In 1952, the Golden Gate Baptist Seminary relocated to the Strawberry Peninsula, joining the San Francisco Theological Seminary in San Anselmo as two additional four-year institutions in Marin County.

Any number of world-famous architects have settled in Marin, but when a new civic center was needed, Marin turned to Frank Lloyd Wright. I. M. Pei was chosen to design the Buck Institute for Age Research.

The rock band era brought Jerry Garcia and the Grateful Dead, Huey Lewis and the News, Carlos Santana, and the famous impresario Bill Graham to Marin County, not to perform, but to live.

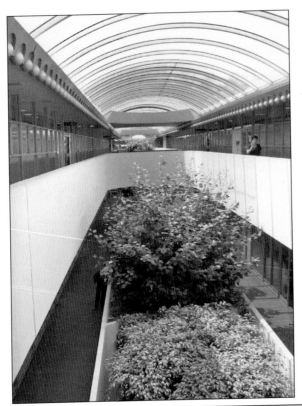

The Marin County Civic Center is renowned for its architecture. It was Frank Lloyd Wright who dreamed of connecting several of Marin's hills with a long slender building built on a series of arches (see cover). The selection of Wright was controversial, but the county wanted a visionary architect with a global reputation.

What proved to be Frank Lloyd Wright's last design and the only government building he designed, the Marin County Civic Center design was faithfully followed by Wright's associates except for adding a roof covering the long corridors, indoor gardens, and rest areas. Wright completed the sketches of all the buildings, including the fair grounds, before his death in 1959. The first phase of the Marin County Civic Center opened in 1961.

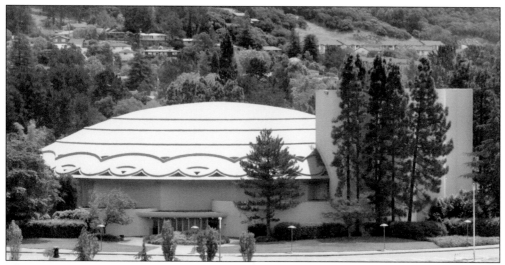

The Marin County Civic Center complex became the heart of Marin's cultural activities and includes an orchestral hall and exhibition center, county offices, courts, and jail. It is the musical home of the Marin Symphony Orchestra.

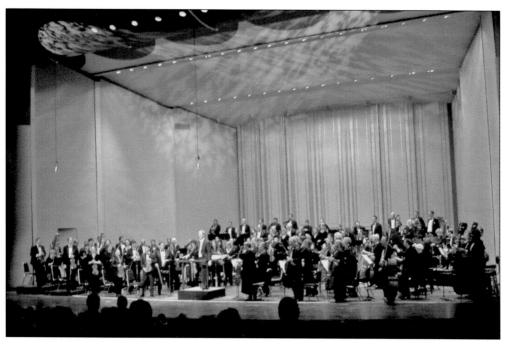

It was in 1950 that a group of musicians formed an orchestral group that rehearsed in a school gymnasium. Fifty years later, the Marin Symphony Orchestra still consists of some community players but also relies on professionals from the San Francisco Symphony. It ranks with the finest regional orchestras in the land. Small but active ballet and opera associations round out the performing arts companies in Marin County.

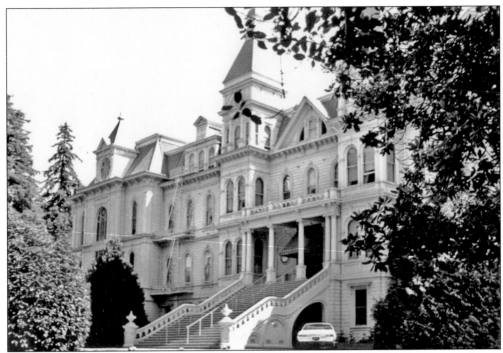

Dominican University of California, located in San Rafael, was founded by Dominican Sisters in 1890 as a school for young girls. A high school and college were added. The high school and lower grades were moved to San Anselmo, and the college became coeducational. As the Dominican Sisters retired, they turned the institution over to a lay board, and it is now completely nondenominational. This beautiful, Victorian-era convent, built of redwood in 1889, was home to 370 nuns at one time. It was destroyed in a fire in July 1990.

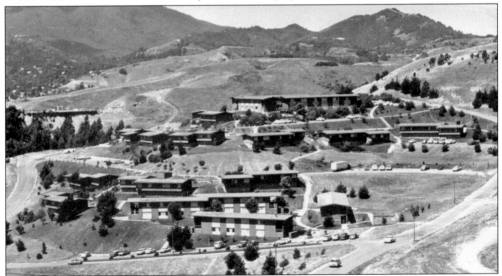

In 1952, the Golden Gate Baptist Seminary relocated from Berkeley to the Strawberry Peninsula. It is a four-year theological institution leading to a degree of doctor of theology. Students live in campus housing and participate in missions worldwide. The site was once considered for the headquarters of the United Nations, but New York won out.

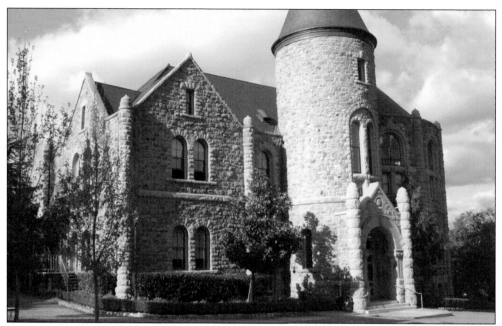

The San Francisco Theological Seminary (SFTS) stands like a French chateau overlooking the Ross Valley. The Presbyterian college traces its roots to several San Francisco–based seminaries founded about 1861. In 1892, the SFTS moved its campus to "salubrious Marin County" to establish a "theological sanitarium of the church." The 14-acre hilltop site has both academic and residential buildings. Degree programs leading to a doctor of ministry are offered.

The College of Marin is part of the California Community College system, providing associate in arts or associate in science degrees after two years and entrée to many four-year universities for those students who wish to pursue further education. The main campus (shown here) is in Kentfield in the Ross Valley. Many of Marin County's nurses and research institution workers are trained at the college.

College of Marin students hang out on their leafy Kentfield campus. The Indian Valley campus is located in a forested area in Ignacio. The technology firms located in Marin County, including AutoDesk and Lucas Arts, draw on the college's graduates for personnel.

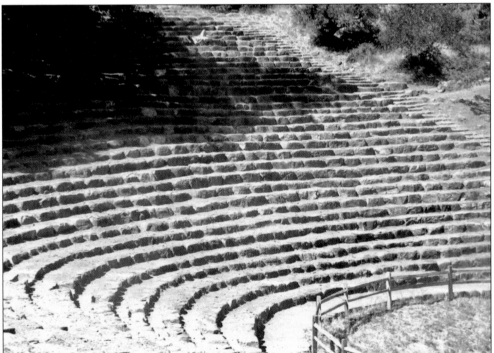

The Mountain Theater is high on the slopes of Mount Tam with a commanding view of the San Francisco Bay as a backdrop. The first performance was in 1912 when 1,200 hikers climbed to the top of the mountain to see a morality play. The 4,000-seat natural amphitheater was built by the Civilian Conservation Corps during the Great Depression.

College of Marin students put on an outdoor version of *Oklahoma!* in the Mountain Theater. From Shakespeare to modern musicals, the College of Marin performing arts department ranks with the best in the Bay Area.

Another costume drama plays out several times a year on Angel Island. Civil War Days allows docents to dress up as Civil War–era army officers or enlisted men and their ladies. The "soldiers" get to fire a cannon in a mock invasion, while the ladies make cookies for visitors in the restored Bake House at Camp Reynolds.

One of Marin County's favorite people was Elizabeth Terwilliger, known far and wide simply as "Mrs. T." Her nature walks with school-aged children were entertaining and informative. Carrying a carload of stuffed and sometimes frozen specimens, Terwilliger demonstrated how Mr. Squirrel and Mrs. Duck survived in the wild. When Pres. Ronald Reagan presented her with a medal at the White House, she soon had him flapping his wings like Mr. Eagle. She died in 2006.

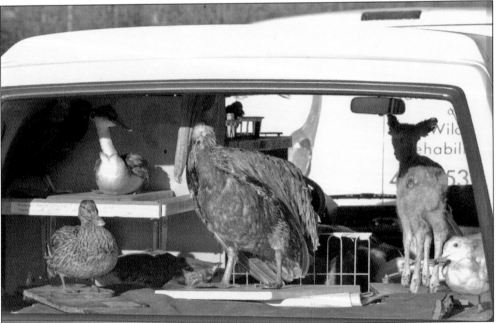

A familiar scene wherever Mrs. T was giving wildlife lectures was her van filled with stuffed critters. She originally kept examples in her home freezer, and children had to pass them around quickly so she could get them back into a cooler before they thawed out. She loved guiding young children through the tide pools so she could show them how Mr. and Mrs. Crab lived under the rocks that she would turn over carefully.

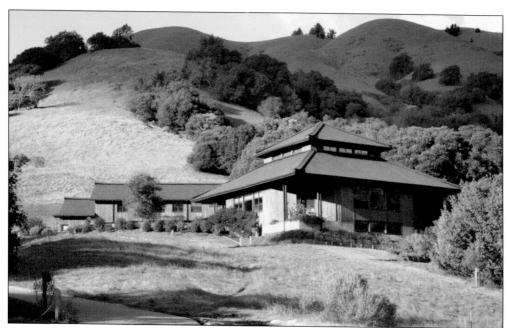

Spirit Rock Meditation Center, located in the San Geronimo Valley, is dedicated to the teachings of Buddha. The practice of mindful awareness, called insight or meditation, is at the heart of all activities at the center. Since locating to San Geronimo Valley in 1987, the center has also been preserving 412 acres of land purchased from the Nature Conservancy.

The residential retreat center opened in 1998. Paths wind through lush gardens highlighted with open-air sanctuaries such as this one with a statue of the Buddha. Religious dignitaries such as the Dalai Lama have visited and taught here.

Thousands of birds pause in their annual migrations to rest and feed at the Richardson Bay Audubon Sanctuary, acquired when a 900-acre portion of the bay was threatened with filling and development. The National and California Audubon Society staff conducts educational programs for 6,000 school-aged children annually to introduce them to the wonders of the natural environment. The historic Lyford House and the cottage of Rose Da Fanta, who donated a 10-acre land portion, are located here.

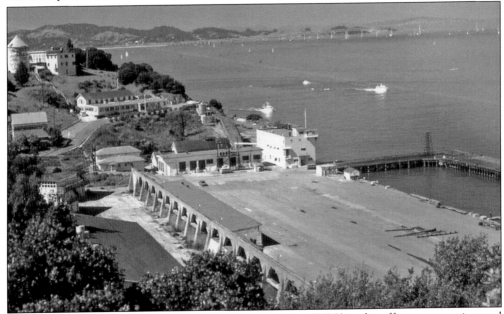

The Romberg Tiburon Center for Environmental Studies (RTC) is the off-campus marine and estuarine research and teaching facility of San Francisco State University to further knowledge of the physical and biological processes of San Francisco Bay and other aquatic environments. RTC occupies a site formerly used by the U. S. Navy as a coaling station and, in World War II, as the base where anti-submarine nets were made.

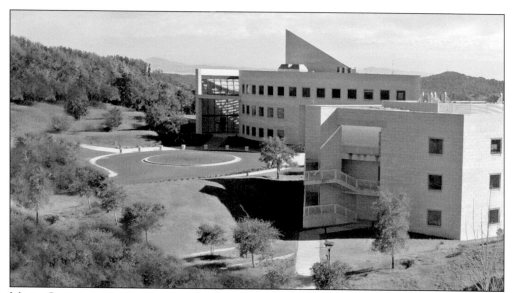

Marin County institutions are involved in research in a wide variety of disciplines. The Buck Institute for Age Research is the only institute in the nation focused solely on research on aging and age-related diseases. Scientists work in a spectacular complex of laboratories and seminar facilities designed by I. M. Pei. They are funded partially by the Marin Community Foundation, with a budget that currently exceeds $1 billion created out of the funds willed to the county by Beryl Buck.

Scientists at the Buck Institute for Age Research in Novato are looking not only to find cures for Alzheimer's, Parkinson's, and other diseases of aging, but also to find ways of extending the life span of humans and the quality of life in their later years. The National Institutes of Health provide additional funding for this research.

A most unusual Sausalito-based research facility has morphed into a public education center. The 1.5-acre San Francisco Bay Model was built by the Army Corps of Engineers in 1957 to test the ebb and flow of the tides and currents in the bay and the impact of developments. The mission is now one of interpretation and education and formulation of water policy relevant to the bay and delta regions.

Marin County has three internationally ranked film festivals each year. The San Rafael, Mill Valley, and Tiburon Festivals show hundreds of documentaries and productions not seen in regular theaters.

Seven

TRANSPORTATION

Two things have had the greatest impact on the living patterns in Marin County: the coming of the railroads and the opening of the Golden Gate Bridge. The second cancelled out the first. The railroads opened the county to permanent residents, and all of the cities and towns were built along the railroad right-of-way. The first railroads were narrow-gauge lines that ran from Sausalito through the Ross Valley to west Marin. A standard-gauge railroad was completed from the redwood forests in the north to southern Marin by 1884.

There was always two-way passenger and freight traffic on Marin County's railroads. Commuters heading for the ferries and San Francisco went one way, and sightseers, picnickers, and vacationers went the other. The redwood forests and ranches sent lumber, hides, tallow, and dairy products to the city, and the railroad carried farm machinery, beer, and whisky back to the country.

Early locomotives were wood burning, then oil burning, and finally diesel electric. The Sausalito commuter line was electrified in 1903, adding a fourth rail to a right-of-way already built to both narrow and standard gauges.

The residents, both north and south of the Golden Gate, had dreamed of a bridge from the earliest days, but it was deemed technically impossible. The water was too deep, the winds and tides were too strong, the span would be too long, and worst of all, it would mar the beauty of the Golden Gate. But finally designers came up with something that would satisfy all these concerns, and the world-famous Golden Gate Bridge was opened to highway traffic in 1937.

The bridge sounded the death knell for Marin County's railroads and ferryboats. One by one, service was discontinued to towns along the way. Where once there were trains leaving towns in west Marin or the Ross Valley every half hour, there were now none. Ferries that could carry 2,000 passengers and 100 automobiles were laid up.

Highway 101, the main artery of Marin County, grew from 2 lanes to 10, and that was still not enough. Traffic backed up for miles. In desperation, residents of Belvedere and Tiburon started their own ferry service using harbor sightseeing vessels. The Golden Gate Bridge District followed with high-speed vessels from Larkspur and Sausalito. The Northwestern Pacific Railroad (NWP) right-of way has been preserved from the Larkspur ferry terminal to north of Santa Rosa, and there have been several attempts at restarting rail service.

ka ht / Daily DAY	82 San Rafael Local	80 San Rafael Local	Distance from San Francisco Via Sausalito		STATIONS	Distance from Willits Via Tiburon	31 Eureka Freight	83 San Rafael Local
	Leave Daily	Leave Daily			Time Table No. 1 — December 2, 1918.		Arrive Daily EX. MONDAY	Arrive Daily
			0.0	DN	**SAN FRANCISCO**	137.9		
5PM	4.30PM	7.00AM	6.5	DNR	**TIBURON**	131.4	2.10AM	5.40PM
	f 4.33	f 7.03	7.5		HILARITA — 1.0 —	130.4		f 5.38
4	f 4.40	f 7.10	10.1		REED — 2.6 —	127.8	1.58	f 5.32
	f 4.45	f 7.15	11.4		SAN CLEMENTE (Spur) — 1.3 —	126.5		f 5.28
5	4.52	7.22	12.7		**DETOUR** — 1.3 —	125.2	1.50	5.23
5	4.52	7.22	14.3		**DETOUR**	125.2	1.50	5.23
0	s 4.55	s 7.25	14.9		GREEN BRAE — 0.6 —	124.6	1.48	s 5.20
	f 4.58	f 7.28	15.7		SCHUETZEN — 0.8 —	123.8		f 5.17
5	5.00PM	7.30AM	17.0	DNR	**SAN RAFAEL** — 1.3 —	122.5	1.35	5.15PM
			18.7		CERRO — 1.7 —	120.8		
7			20.0		GOLF — 1.3 —	119.5	1.15	
			21.1		GALLINAS (Spur) — 1.1 —	118.4		
5			21.7		MILLER — 0.6 —	117.8	1.10	
			22.0		ST. VINCENT (Spur) — 0.3 —	117.5		
0			24.9	DNR	**IGNACIO** — 2.9 —	114.6	12.55	
9PM			27.8	D	NOVATO — 2.9 —	111.7	12.26	
6AM			31.3		BURDELL — 3.5 —	108.2	12.16AM	
5			36.7		HAYSTACK — 5.4 —	102.8	11.59PM	
			37.6		**JUNCTION** — 0.9 —	101.9		
5			38.5	D	PETALUMA — 0.9 —	101.0	11.53	

(Center: "Automatic Block"; "Double Track" between Detour and San Rafael)

The early timetables of the NWP included most of the stops that eventually became cities and towns. The first trains ran from Sausalito north through Corte Madera, Larkspur, and out through the Ross Valley. San Rafael was served by a spur from San Anselmo. By 1884, a direct line from San Rafael to Tiburon was completed.

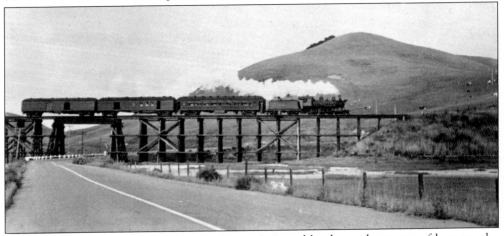

Steam-powered trains negotiated Marin County's rugged landscape by means of long trestles and numerous tunnels. This one, near the NWP terminus in Tiburon, gave the swampy area its name: Trestle Glen.

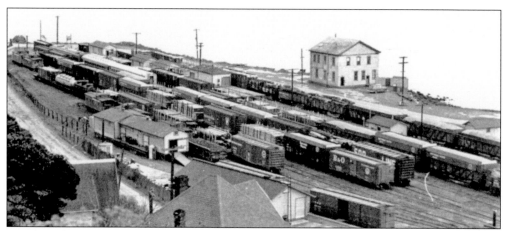

Peter Donahue, an Irish blacksmith from Dublin, started making boilers in San Francisco. This led to making locomotives, then whole railroads, and finally ferry boats to connect everything. In 1884, he closed the last link by blasting out a railroad yard in Tiburon. Donahue also founded the Union Iron Works and the Pacific Gas and Electric Company, two of San Francisco's largest industries.

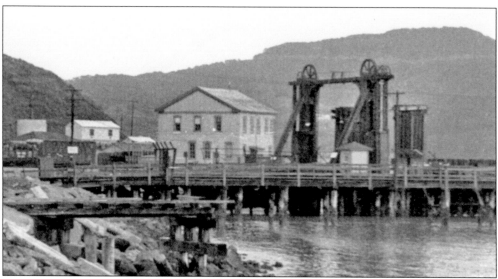

The NWP terminal in Tiburon was unique: it was both a rail and ferry terminal. The two terminals had complete repair shops for both freight and passenger cars and locomotives, and also could build them. The largest ferries on the San Francisco Bay were built and maintained here. This apparatus, known as a gallows frame, adjusted the tracks to changing tides. It dominated the Tiburon waterfront for many years.

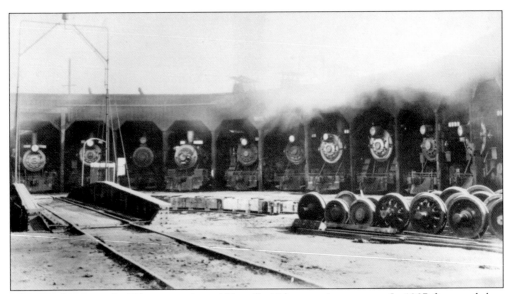

The roundhouse in the Tiburon yards could handle 11 locomotives at once. In 1907, five north-bay rail lines were combined to form the Northwestern Pacific Railroad, jointly owned by the Santa Fe and the Southern Pacific Railroads. It was decided to direct most passenger service through Sausalito and all freight to Tiburon. Maintenance on rail equipment and the ferries would also remain in Tiburon.

Sausalito became a busy passenger terminal after the merger. The former narrow-gauge railroad was still used, but the new rail line requires standard-gauge tracks, so there were three running down Bridgeway. After the line was electrified, a fourth rail was added to carry the electric current.

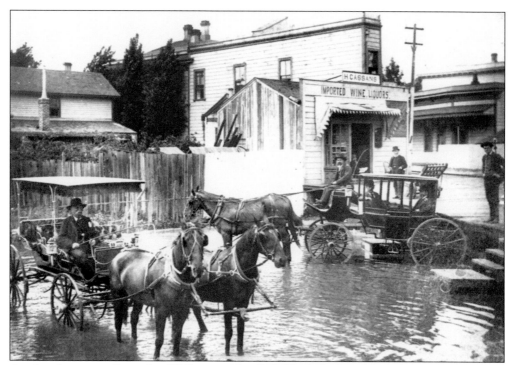

A railroad station at Second and B Streets in San Rafael had a little problem when it rained in 1896. (Courtesy Marin History Museum.)

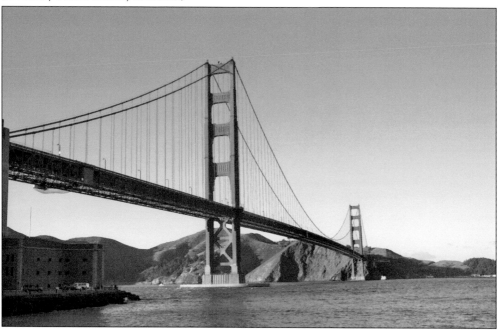

The gateway to Marin County from the south is the Golden Gate Bridge, one of the most recognizable landmarks in the world. The Golden Gate Bridge is anchored on one end in the Presidio, the 1,100-acre former San Francisco headquarters of the U.S. Army. The other end is in the Marin Headlands.

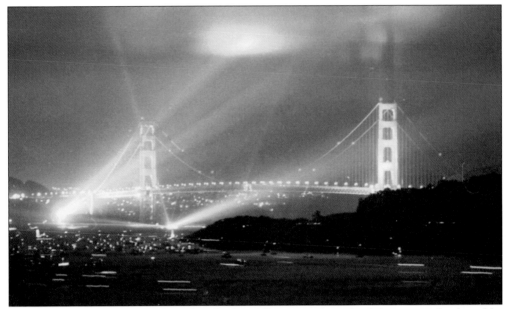

The people of Marin County love their bridges. They even throw birthday parties for them like this 50th birthday celebration for the Golden Gate Bridge, when 250,000 people turned out to walk across it. One hundred thousand tons of steel and 80,000 miles of wire went into the construction of the bridge.

The north end of the Golden Gate Bridge leads directly into two tunnels. This is the foggy side of the gate. Frequently, the sky is blue and cloudless when exiting the tunnel on the Marin County side. The arched tunnel faces on the south ends have been painted as rainbows, and visitors can draw their own conclusions as to the thought behind this artistry.

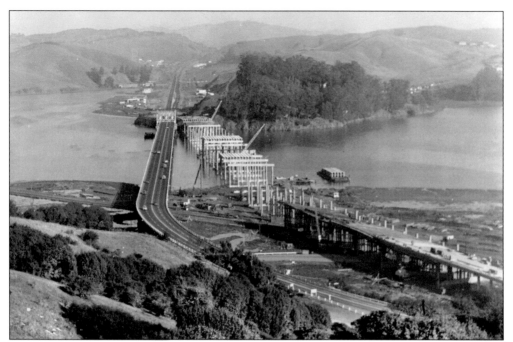

When the Golden Gate Bridge was built, the low-level Highway 101 was a narrow four-lane road with a drawbridge over an arm of Richardson Bay. A new highway was finally built on a causeway high enough to allow small craft to pass underneath. It has been expanded again and again, and still never seems to have enough lanes to handle the traffic.

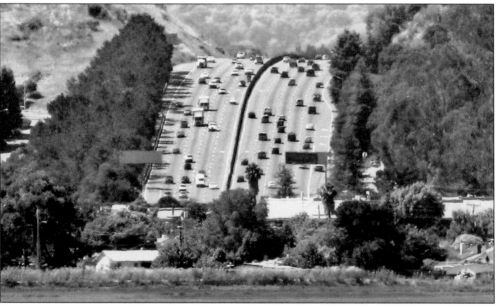

Beginning as a stagecoach line that followed an old Native American trail, Highway 101 is the vital link that ties everything together in Marin County. It was large enough when it primarily served Marin commuters going to San Francisco, but now many commuters from outside the county coming to or through the county have made it inadequate again. HOV lanes have been added, but they fill up just as fast.

Call it a roller coaster or an ugly duckling, but Marin County's connection to the East Bay is the Richmond San Rafael Bridge. A long causeway was built leading out of San Rafael, and then a cantilevered section was built high enough for ships en route to Sacramento, Stockton, and the other river ports to pass. Then the road goes back down to a lower level before rising to another cantilevered section, then back down to the toll plaza on the Richmond end. This supposedly saved money in construction.

The ferryboat *Ukiah* was built in the railroad yards in Tiburon in 1890. It could carry more than 2,000 passengers and 16 railroad cars. It was the largest double-ended ferry in the world. After World War I, it was so worn out that it was rebuilt and could then carry 3,000 passengers and 100 automobiles. It was renamed *Eureka* and is now moored in the historic ship collection in San Francisco.

Newer, faster ferries are in use today. The double-hulled *Mendocino* ties up at the modernistic terminal at Larkspur Landing. The Golden Gate Bridge Highway and Transportation District operates a fleet of boats from Larkspur and Sausalito and a network of busses in an attempt to divert traffic from Highway 101 and the bridge.

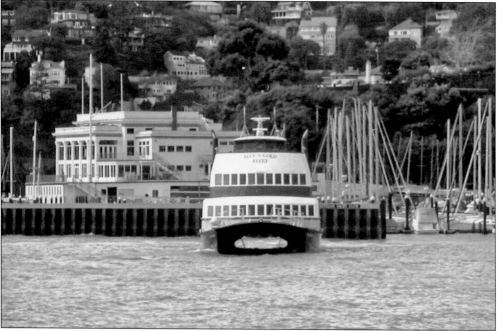

The MV *Zelinsky* is a double-hulled fast ferry that travels from Tiburon to San Francisco and is operated by a private sightseeing-cruise company, the Blue and Gold Fleet. It makes the crossing in about 18 minutes. None of the ferries operating today carry automobiles.

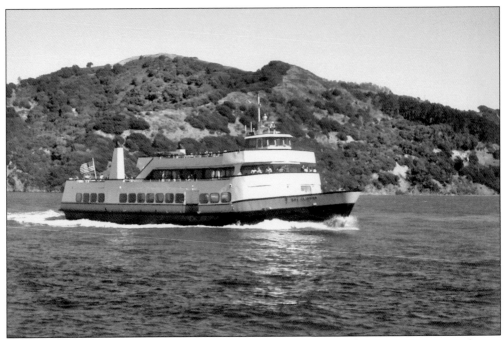

The Blue and Gold Fleet also operates ferries to Angel Island from San Francisco during the summer months.

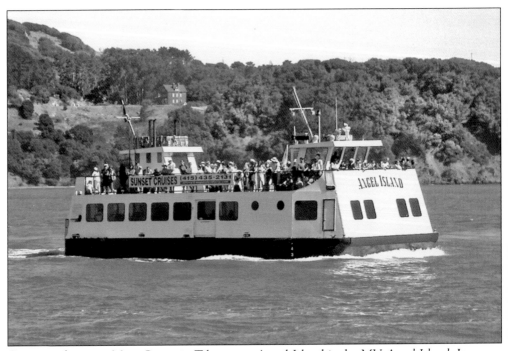

Operating between Main Street in Tiburon to Angel Island is the MV *Angel Island*. It runs a regular schedule for the 20-minute ride while loaded with bicyclists, back packers, campers, and picnickers. The island is now a state park hosting 250,000 visitors each year.

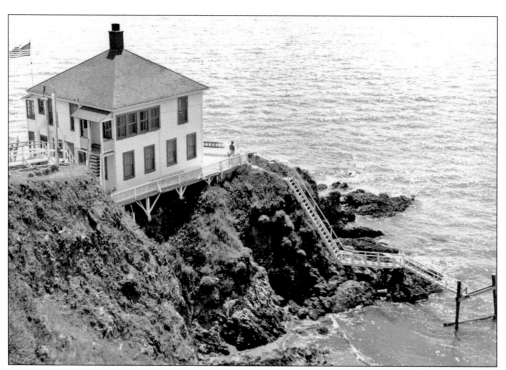

San Francisco Bay is one of the busiest ports in the world. Many ships pass through the Golden Gate and then turn north, headed for Richmond, Sacramento, Stockton, and the former Mare Island naval base. Maritime safety required three lighthouses on Angel Island at one time. An automated one is still operational. This beautiful residence of the lighthouse keepers was destroyed. No longer relevant to maritime safety, the GGNRA has taken over the Point Bonita, Lime Point, and Point Diablo lighthouses on the Golden Gate.

The Chinese that continued to come to "Gold Mountain," as they called California, were held at the Angel Island Immigration Station until their status could be investigated. Poems carved into the walls of their dormitories are being preserved as a National Trust.

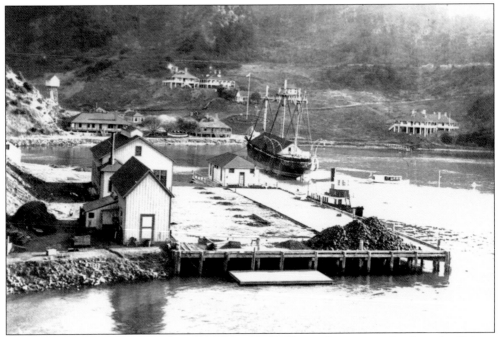

San Francisco's busy seaport was potentially a gateway for epidemics to arrive from the Orient. A quarantine station was opened by the Public Health Service on Angel Island in 1891. Passengers, baggage, and freight were fumigated and often held in quarantine if any disease was found onboard.

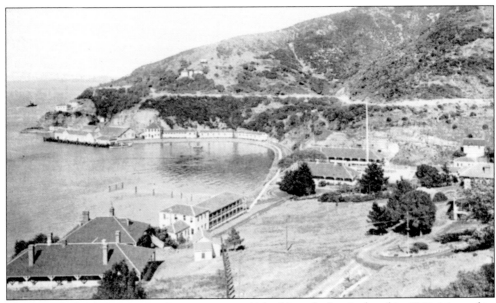

The Angel Island Quarantine Station grew to 44 buildings before it closed in 1940. Most of its buildings were deliberately destroyed before it became state park.

Eight

SPORTS AND RECREATION

Since the days when the first Spanish-speaking settlers enlivened their quiet, pastoral life with traditional rodeos to the opening hill climb of the Tour of California bicycle race, Marin County has been a magnet for outdoor sports. From the 1860s to the 1930s, Bay Area residents flocked to Marin on weekends to sail, hike, picnic, camp out, ride the trains, play tennis or golf, ride horseback, or enjoy the fabulous views. The ferries from San Francisco to Sausalito and Tiburon were jammed on weekends.

Waiting trains would take holiday seekers to picnic grounds and campsites on the slopes of Mount Tam high above Mill Valley or out to Stinson Beach or Inverness. A few dollars could buy a tiny lot on which to pitch a tent or even build a small cabin. Extended families and generations of friends gathered at the same place year after year. The trains are gone, but hiking and bicycle trails have replaced them.

Saturday night dances at the Rosebowl in Larkspur attracted 3,000 to 5,000 well-behaved guests. Pastori's Hotel and Restaurant (later the Marin Town and Country Club) in Fairfax, with swimming pools, tennis courts, and a dance pavilion, brought thousands more to Marin County.

The Point Reyes National Seashore, Golden Gate National Recreation Area, Mount Tamalpais, Samuel Taylor and Angel Island State Parks, and the Muir Woods National Monument still bring millions of outdoor visitors to Marin County each year. Dozens of private and public tennis, golf, and swim clubs have been added since the end of World War II.

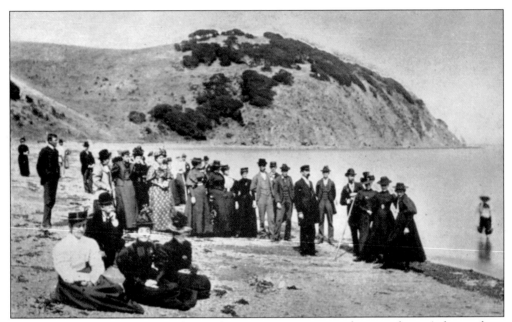

A day outing in Marin County during the Victorian era required proper dress. A ferry ride to Tiburon and a stroll on the beach, followed by a picnic lunch in a secluded cove, was a popular schedule. A daring woman on the right even went for a wade. El Campo was a popular place for outings and could only be reached by ferry; therefore, it was "free from San Francisco ruffians whose main pleasure was disrupting family outings in Marin."

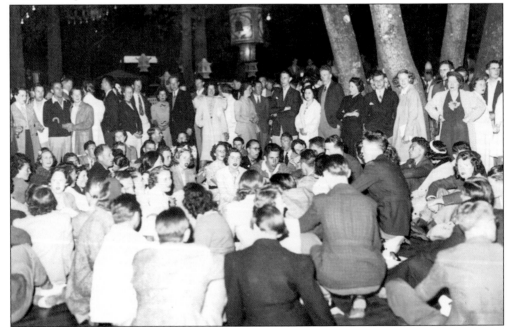

The Fairfax estate was called "Birds Nest Glen" until it was sold in 1870. The buyers, Charles and Adele Pastori, turned it into a highly respected Italian restaurant just steps away from the railroad station and then a resort with popular bands and dancing, and overnight cabins. (Courtesy Marin History Museum.)

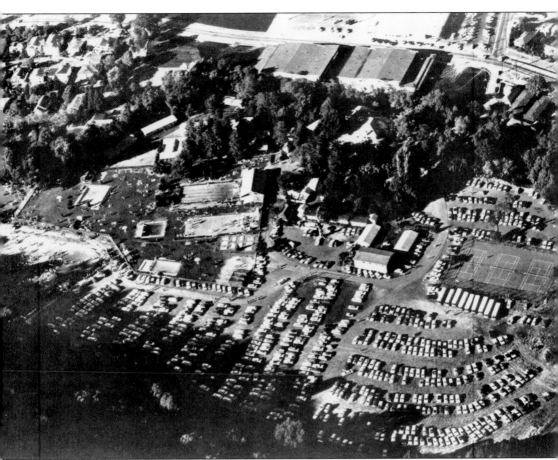

The Emporium Department Store bought the resort in 1925 and operated it for its employees until World War II. After the war, it became the Marin Town and Country Club, drawing throngs from around the Bay Area to its six swimming pools, Redwood Bowl pavilion, and sports fields. By car, bus, and train, visitors came to play though the day and dance through the night. It closed in 1972. All attempts to reopen the resort have failed to gain the approval of the City of Fairfax. (Courtesy Marin History Museum.)

Beginning with the shoreline path in Tiburon in the early 1970s, a network of bicycle and pedestrian corridors spread throughout Marin County. This one makes use of the former Northwestern Pacific Railroad right-of-way and borders on the 900-acre Richardson Bay Audubon Sanctuary. A popular bike route from San Francisco is across the Golden Gate Bridge, through Sausalito and Mill Valley, to Tiburon, ending with a ferry ride back to the city.

The ultimate in bicycling is the Tour of California, California's answer to the Tour de France. The race is from Marin County to Long Beach in Southern California. The first leg is from Sausalito to Santa Rosa. The "peloton," or main pack of riders, grind their way over the Panoramic Highway on Mount Tamalpais.

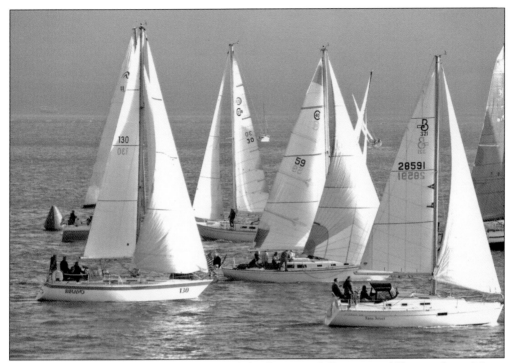

With water on three sides, it was only natural that boating of all types would be popular in Marin County. There are numerous yacht clubs, and whole communities such as Strawberry, Corte Madera, Paradise Cay, and Bel Marin Keys are built around waterways. Corte Madera Creek is home to several rowing clubs, including Redwood High School's crew.

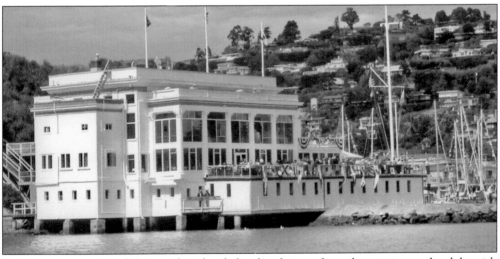

In 1886, a group of small-boat sailors decided to break away from the existing yacht clubs with their professional skippers and formed the Corinthian Yacht Club. After their first clubhouse burned down, they opened this new clubhouse in 1912 between Belvedere and Tiburon. With its distinctive columns, it is a highly visible landmark for the entire Bay Area.

The Meadow Country Club golf course was designed by one of golf's greatest architects, Dr. Alister MacKenzie, who also designed Cypress Point, Augusta National, and Pasatiempo golf courses. It is high on the slope of Mount Tam near Alpine and Bon Tempe Lakes of the Marin Municipal Water District. It is one of two private and six public golf courses in the county.

In addition to the vast state, county, and federal parklands in Marin County, almost every school has a basketball court and ball fields for Little League and team sports. This all-weather soccer/football/track field at Redwood High School in Larkspur is in constant use.

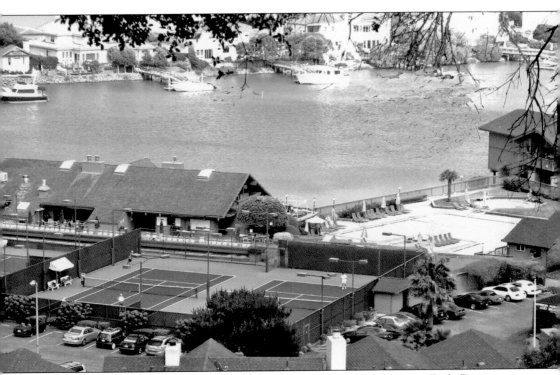

One of the most popular tennis clubs is at Harbor Point on the site of the pioneer Eagle Dairy on the Strawberry Peninsula. It hosts several national tournaments each year and has had touring professionals on its teaching staff.

The horse was a means of transportation for the earliest settlers. Most of our main roads follow the routes laid out for the stagecoaches and equestrians of the past. There are still equestrian trails throughout all of West Marin, but the riding is for pleasure.

A saddle horse named Blackie was retired by his owner to a waterfront pasture in Tiburon. He was so beloved by all the children that when he died in 1966 at age 40 a life-sized statue was installed in Blackie's Pasture where he was buried.

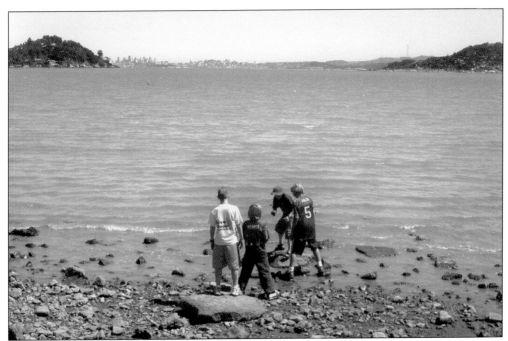

These young boys plot their next adventure. They still have lots of choices in a hometown surrounded by water, forests, and mountains.

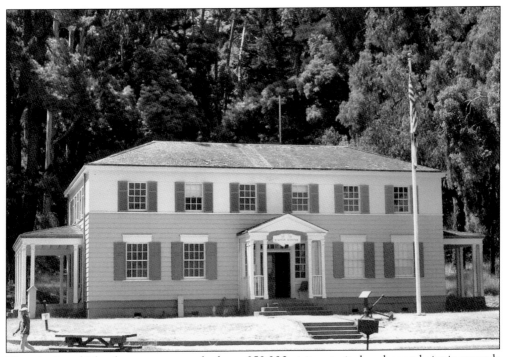

Historic Angel Island, now a state park, draws 250,000 visitors to its beaches and picnic grounds each year. The administration building from the former quarantine station is the park headquarters and visitor center.

Camp Reynolds on Angel Island provides overnight camping for scout troops and class outings.

Eight hundred hearty souls participate in the Tiburon Mile, an annual race across Raccoon Strait from Angel Island to the Corinthian Yacht Club. Participants are in three classes; serious, open-water swimmers; those who wear wet suits; and all the rest.

Without major college or professional teams in Marin County, the emphasis is on youth sports. The Little League baseball games are big time in some towns. Several thousand boys and girls play Little League ball during grammar school years and then move on to high school teams.

One local ball player who did not stop with high school sports was Sam Chapman, who starred in four sports at Tamalpais High School. He played football, baseball, and basketball at the University of California–Berkeley. Turning professional upon graduation, Chapman starred for the Philadelphia Athletics for a decade and flew for the navy during World War II. He died in Tiburon in 2006.

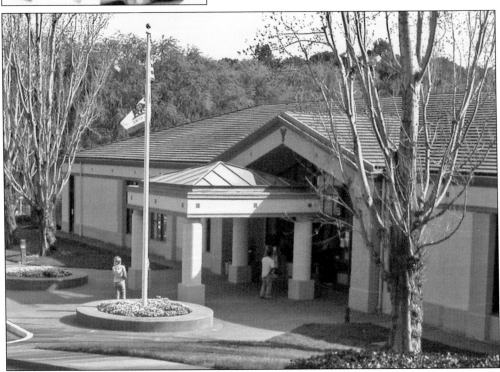

For years, the Marin YMCA operated out of an old farmhouse and borrowed backyard pools. Hiking and camping were the main activities. Finally, in 1987, a full-service YMCA was built in San Rafael with more than 3,000 members. A single stationary bicycle and a rowing machine has evolved into entire rooms and corridors filled with modern exercise equipment. Basketball and handball are still popular.

Nine

MILITARY MARIN

On December 7, 1941, two squadrons of aircraft were approaching Hawaii. One was from a fleet of Japanese aircraft carriers; the other was a flight of B-17s from Hamilton Field in Marin County. The B-17s were unarmed and almost out of fuel, but after being alerted that an attack was underway, they scattered to alternate fields. As the westernmost continental airfield, Hamilton was the jumping-off point for thousands of aircraft heading to the Pacific wars.

Except for the skirmish at Olompali in 1846, Marin County has been spared any actual combat. Marin's military bases have been an important part of the nation's defenses since the Civil War. Muzzle-loading cannons in the Marin Headlands and on Angel Island guarded the Golden Gate, and troops trained on Angel Island. Troops based in Marin participated in the Indian Wars and again in World Wars I and II. When the U.S. Navy burned coal for fuel, a coaling station was established in Tiburon, and in World War II, the facility was used to make anti-submarine nets to guard the harbors.

After the attack on Pearl Harbor, the Japanese captured almost every shipyard west of Honolulu, and the United States was planning to send a thousand ships in harm's way. Floating drydocks were built in Bay Area shipyards, and the crews to man them were trained at the Floating Dry Dock Training School, also located in Tiburon. They followed the fleet wherever repairs might be needed. Shipyards sprang up overnight in the mudflats of Sausalito.

The cold war brought the U.S. Air Force to Mill Valley to defend against enemy bombers. Huge silver domes sprouted on the top of Mount Tamalpais containing radar that could look far out to sea. Nike missiles hidden in underground silos in the Marin Headlands and Angel Island were to be launched by the army and then controlled by air force officers located on Mount Tam.

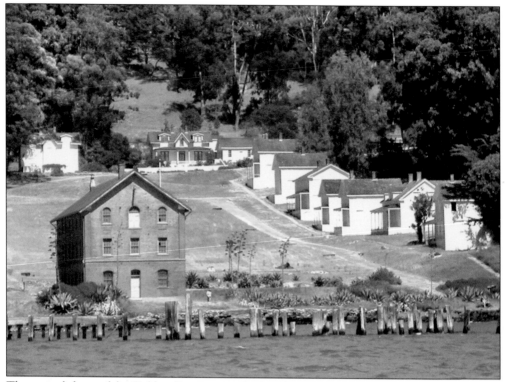

The main defense of the Golden Gate was on the San Francisco side—Fort Point. The equivalent fort on the Marin County side was never built because the military relied on installations on Alcatraz and Angel Islands to defeat any ships that had made it into the Bay. Camp Reynolds was built on Angel Island during the Civil War to house the troops manning the guns mounted at Fort Knox.

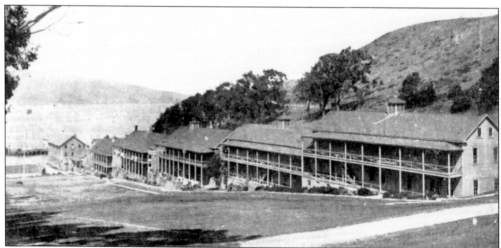

Not only were the Confederate warships a concern, but the British Pacific Fleet was also lurking off shore, perhaps hoping the distraction of the Civil War would allow them to take control of California. Troops based on Angel Island fought in the Indian Wars in the West, the Spanish American War and the Philippine Insurrection, and World Wars I and II. These enlisted men's barracks have been torn down, but officers' row, on the other side of the parade ground, still stands.

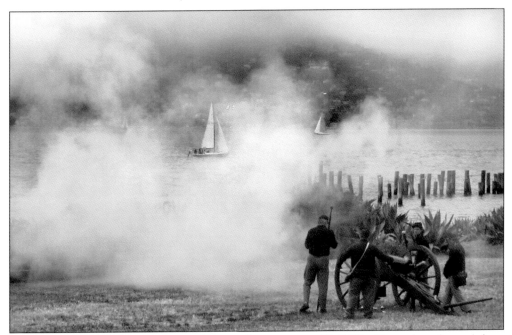

The only guns fired these days are ceremonial cannons on Civil War Days when docents dress in period costumes and entertain visitors.

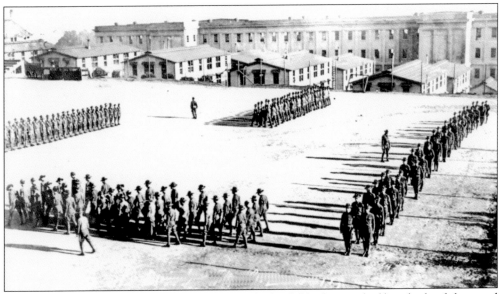

The parade ground at Fort McDowell on Angel Island felt the tread of hundreds of thousand of troopers and GIs from the Spanish American War until the end of World War II. More than 300,000 men passed through the island's bases when it was part of the San Francisco Port of Embarkation in World War II.

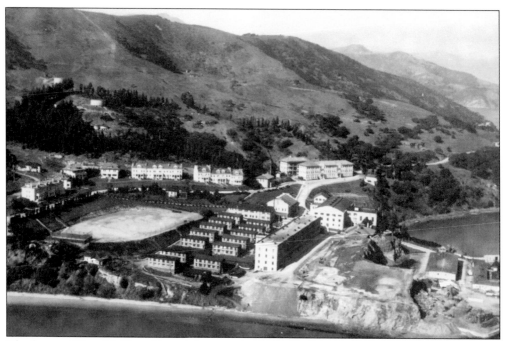

The heart of Fort McDowell's activity was the 1,000-man barracks. Surrounding them were a mess hall serving as many as 12,600 meals per day, a post exchange complete with soda fountain and taproom, and a guardhouse. The officers' row of Victorian-style homes is still used by park employees.

When Angel Island became a state park, almost 200 buildings were burned or demolished. The large concrete and steel buildings were left standing but gutted to prevent unauthorized use. They look like abandoned movie sets that you can see right through.

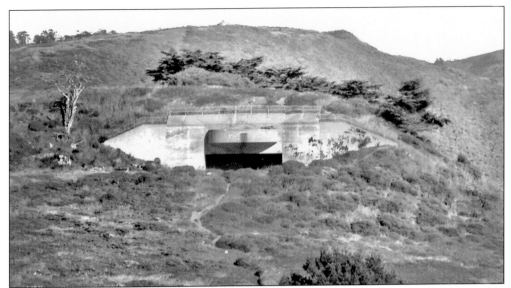

In 1941, Fort Cronkhite was built at the Pacific entrance to the Golden Gate. It had guns that weighed 150 tons and could fire a 16-inch projectile 32 miles out to sea. Impregnable bunkers were being built when the guns became obsolete. The bunkers and the 84 buildings belonging to Fort Cronkhite are a part of the GGNRA. The buildings are used for art centers, meetings, and a YMCA conference center.

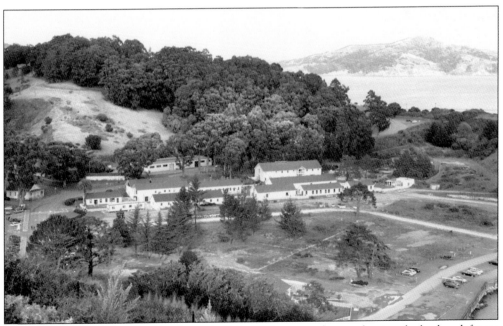

Fort Baker on the Marin Headlands was built in 1897 as part of strengthening the harbor defenses during the Spanish American War. Rifled cannons with a range of 12 miles were installed. In 1907, Fort Barry was split from Fort Baker, and 50 more guns were mounted. A 2,200-foot tunnel was dug to connect the two.

When the U.S. Navy's Pacific Fleet ran on coal, ships called colliers would bring coal to a base in Tiburon, where ships of the fleet would line up and refuel. In 1909, when President Roosevelt decided to send the navy around the world on a goodwill cruise, the fleet had to stop in Marin County to refuel before continuing onward across the Pacific.

When the navy switched to oil to fuel the fleet, the large gantry cranes were removed, and the site was used to spin the suspender cables for the Golden Gate Bridge. The name was changed during World War II to the U.S. Navy Net Depot, Tiburon. Huge anti-submarine nets were constructed here, and crews were trained in their installation and operation.

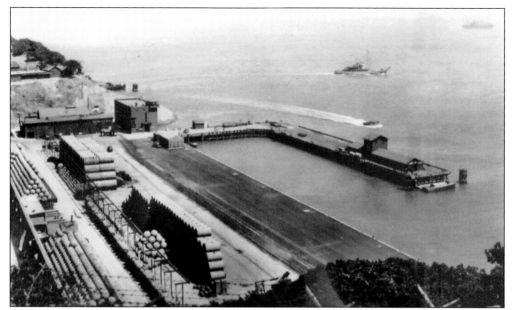

Ports on the Pacific Coast and throughout the Pacific theater of operations were protected with antisubmarine nets until the end of World War II when most of the nets came back for dismantling and salvage. The site where the navy made the nets is now the Romberg Tiburon Environmental Center, a research facility operated by San Francisco State University. Renowned for estuarine research, the laboratories and conference facilities draw scientists from around the world.

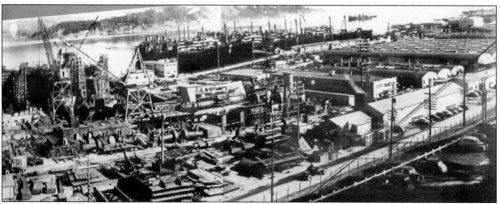

In December 1941, the call went out for 5,000 new vessels to rebuild the navy and merchant fleet. Three months after the attack on Pearl Harbor, the waterfront of Sausalito was transformed into a shipyard. Workers were recruited from around the country, trained in new skills, and housed in a new town (Marin City). Ninety-three Liberty ships and tankers were built in 3.5 years. Ship workers produced one ship every 13 days; one was built from the keel up in 33 days.

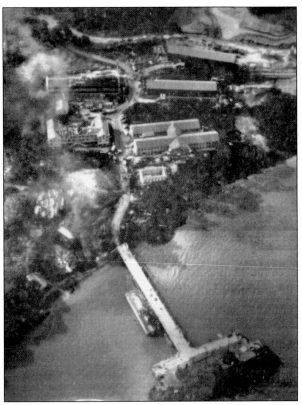

If these ships were going to go into harm's way along with the rest of the fleet, then ship repair facilities would have to go with them. However, the Japanese had captured all the ship repair facilities west of Pearl Harbor. The Floating Dry Dock Training School was established in Tiburon to train navy personnel who would take this unique ship repair facility with the fleet into combat.

By far the largest military installation in Marin County was Hamilton Field at 927 acres. The people of Marin purchased the land and gave it to the federal government in 1930 in order to create jobs in the county. Hangars large enough to house the largest planes of that era were built. The field opened for service in 1935. The Coast Guard still has operations there.

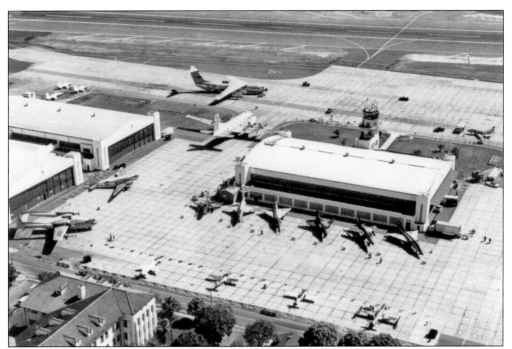

A wide variety of aircraft were based at Hamilton, beginning with Martin bombers of the 7th Bombardment group. As war loomed, the group was replaced by fighter groups flying P-36s and P-40s. Lockheed Lightening P-38s were stationed at Hamilton in 1942. Intercontinental bombers and jet fighters followed during the cold war.

Hamilton Field was one of the first to feel the effect of the Base Closing Act. The huge hangars have been converted into offices and the officers' homes sold. Hundreds of new homes have been built on the open land, and the dykes have been breached, flooding the runway that was below the level of the San Francisco Bay. The main gate has been preserved as a memorial to the thousands of airmen who served their country.

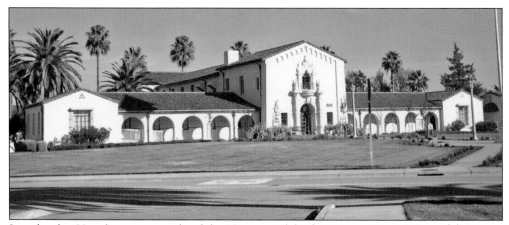

In its heyday, Hamilton was considered the "Country Club of Air Bases." Marin's Spanish/Mexican heritage was reflected in the design of the hundreds of homes and offices built on the base. The base administration building was typical of the construction. These are all being reused.

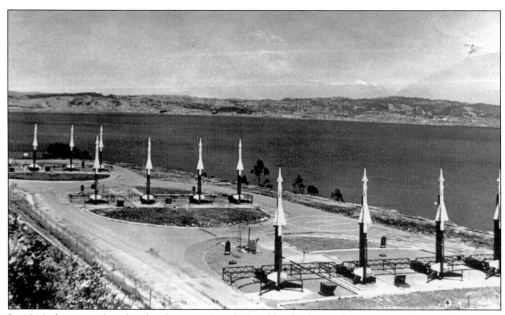

In 1946, the army closed its last base on Angel Island but had to reclaim a part of it in 1954 as a ring of Nike missile bases was constructed around the Bay Area to defend against Russian bomber attacks. The Nike missiles were stored underground and raised to the surface to be fired. Once airborne, control passed to the Mill Valley Air Force Base on top of Mount Tamalpais. The missiles were obsolete by 1962 and removed, but underground silos are still located around Marin County.

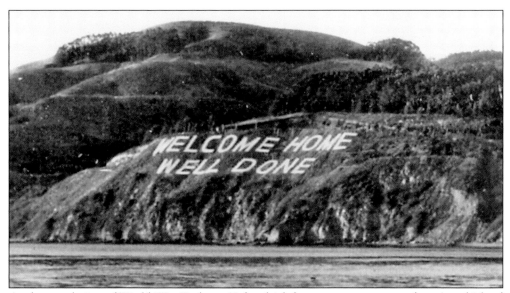

At the conclusion of World War II, these 60-foot-high letters were constructed on Angel Island to welcome home the troops who fought the war in the Pacific.

There are many reminders of the part that Marin County played in national defense, but to honor the men and women who sailed though the Golden Gate and never returned, a statue of a "Lone Sailor" was erected at Vista Point. The navy has patrolled the coast since the 1800s and played a significant role in obtaining California from Mexico. The Coast Guard has maintained lighthouses and lifesaving stations in Marin County and still has a marine radio station at Point Reyes.

www.arcadiapublishing.com

MAP SEARCH

Discover books about the town where you grew up, the cities where your friends and families live, the town where your parents met, or even that retirement spot you've been dreaming about. Our Web site provides history lovers with exclusive deals, advanced notification about new titles, e-mail alerts of author events, and much more.

MADE IN THE
USA

Arcadia Publishing, the leading local history publisher in the United States, is committed to making history accessible and meaningful through publishing books that celebrate and preserve the heritage of America's people and places. Consistent with our mission to preserve history on a local level, this book was printed in South Carolina on American-made paper and manufactured entirely in the United States.

This book carries the accredited Forest Stewardship Council (FSC) label and is printed on 100 percent FSC-certified paper. Products carrying the FSC label are independently certified to assure consumers that they come from forests that are managed to meet the social, economic, and ecological needs of present and future generations.

FSC
Mixed Sources
Product group from well-managed
forests and other controlled sources

Cert no. SW-COC-001530
www.fsc.org
© 1996 Forest Stewardship Council

Find Your Place in History.